Contemporary Art: A Very Short Introduction

VERY SHORT INTRODUCTIONS are for anyone wanting a stimulating and accessible way into a new subject. They are written by experts, and have been translated into more than 45 different languages.

The series began in 1995, and now covers a wide variety of topics in every discipline. The VSI library currently contains over 650 volumes—a *Very Short Introduction* to everything from Psychology and Philosophy of Science to American History and Relativity—and continues to grow in every subject area.

Very Short Introductions available now:

ABOLITIONISM Richard S. Newman
THE ABRAHAMIC RELIGIONS
 Charles L. Cohen
ACCOUNTING Christopher Nobes
ADAM SMITH Christopher J. Berry
ADOLESCENCE Peter K. Smith
ADVERTISING Winston Fletcher
AERIAL WARFARE Frank Ledwidge
AESTHETICS Bence Nanay
AFRICAN AMERICAN
 RELIGION Eddie S. Glaude Jr
AFRICAN HISTORY John Parker and
 Richard Rathbone
AFRICAN POLITICS Ian Taylor
AFRICAN RELIGIONS
 Jacob K. Olupona
AGEING Nancy A. Pachana
AGNOSTICISM Robin Le Poidevin
AGRICULTURE Paul Brassley and
 Richard Soffe
ALBERT CAMUS Oliver Gloag
ALEXANDER THE GREAT
 Hugh Bowden
ALGEBRA Peter M. Higgins
AMERICAN BUSINESS HISTORY
 Walter A. Friedman
AMERICAN CULTURAL HISTORY
 Eric Avila
AMERICAN FOREIGN RELATIONS
 Andrew Preston
AMERICAN HISTORY Paul S. Boyer
AMERICAN IMMIGRATION
 David A. Gerber
AMERICAN LEGAL HISTORY
 G. Edward White

AMERICAN MILITARY HISTORY
 Joseph T. Glatthaar
AMERICAN NAVAL HISTORY
 Craig L. Symonds
AMERICAN POLITICAL HISTORY
 Donald Critchlow
AMERICAN POLITICAL PARTIES
 AND ELECTIONS L. Sandy Maisel
AMERICAN POLITICS
 Richard M. Valelly
THE AMERICAN PRESIDENCY
 Charles O. Jones
THE AMERICAN REVOLUTION
 Robert J. Allison
AMERICAN SLAVERY
 Heather Andrea Williams
THE AMERICAN WEST Stephen Aron
AMERICAN WOMEN'S
 HISTORY Susan Ware
ANAESTHESIA Aidan O'Donnell
ANALYTIC PHILOSOPHY
 Michael Beaney
ANARCHISM Colin Ward
ANCIENT ASSYRIA Karen Radner
ANCIENT EGYPT Ian Shaw
ANCIENT EGYPTIAN ART AND
 ARCHITECTURE Christina Riggs
ANCIENT GREECE Paul Cartledge
THE ANCIENT NEAR EAST
 Amanda H. Podany
ANCIENT PHILOSOPHY Julia Annas
ANCIENT WARFARE
 Harry Sidebottom
ANGELS David Albert Jones
ANGLICANISM Mark Chapman

For more information visit our website

www.oup.com/vsi/

Julian Stallabrass

CONTEMPORARY ART

A Very Short Introduction

SECOND EDITION

OXFORD
UNIVERSITY PRESS

OXFORD
UNITED PRESS

Great Clarendon Street, Oxford, OX2 6DP,
United Kingdom

Oxford University Press is a department of the University of Oxford.
It furthers the University's objective of excellence in research, scholarship,
and education by publishing worldwide. Oxford is a registered trade mark of
Oxford University Press in the UK and in certain other countries

First published in hardback as *Art Incorporated* 2004
First published as a *Very Short Introduction* 2006
This edition published 2020

Impression: 1

Published in the United States of America by Oxford University Press
198 Madison Avenue, New York, NY 10016, United States of America

British Library Cataloguing in Publication Data
Data available

Library of Congress Control Number: 2020943761

ISBN 978-0-19-882662-0

Printed in Great Britain by
Ashford Colour Press Ltd, Gosport, Hampshire

To Peter and Audrey

Contents

Acknowledgements

While this book takes a position against much of the literature written on contemporary art, that writing has nonetheless formed it, and I would like to express my appreciation to all those who appear in the References section. To state the obvious, a book of this length can only be an introduction, and has to exclude vastly more than it can encompass. There would be many other and equally valid ways of approaching this complex and controversial subject. The inclusion of artists and works should not be seen as implying any judgement of quality but is instead an indication of their relevance to the book's core concerns: the regulation and incorporation of art in the world order since 1989. I would urge readers to use this account as a staging post to go on to find more detailed analyses of subjects that can only be dealt with summarily here.

I have benefited greatly from conversations with many artists, academics, critics, and curators, and particularly from colleagues and students at the Courtauld Institute of Art. Many thanks also to Sarah James and Hyla Robiscek, who helped my research. Thanks also to all those at Oxford University Press, particularly to Katharine Reeve who nurtured this project, and to Jenny Nugee and Latha Menon who worked on this updated edition.

Parts of this book have been previously published in the following places, although these passages have been substantially altered for their appearance here:

'Shop until You Stop', in Schirn Kunstalle Frankfurt / Tate Liverpool, *Shopping: A Century of Art and Consumer Culture*, ed. Christoph Grunenberg and Max Hollein (Ostfildern-Ruit: Hatje Cantz Publishers, 2002).

'Free Trade/Free Art', in Neil Cummings / Marysia Lewandowska, *Free Trade* (Manchester: Manchester Art Gallery, 2003).

List of illustrations

The publisher and the author apologize for any errors or omissions in the above list. If contacted they will be pleased to rectify these at the earliest opportunity.

Chapter 1
A zone of freedom?

Think first of the use contemporary artists make of human bodies: hair teased into patterns that form Chinese characters, or woven into a rug, or plucked from the artist's body to be inserted into a diminutive waxwork rendition of the corpse of the artist's father; blood let drip from self-inflicted wounds onto canvas, or made into a self-portrait bust; marks made on drawings—or over crucifixes—by ejaculating over them; cosmetic surgery undergone as performance art; human ears grown in Petri dishes; a baby's corpse cooked and (apparently) eaten. Contemporary art seems to exist in a zone of freedom, set apart from the mundane and functional character of everyday life, and from its rules, conventions, and bureaucratic procedures. In that zone, alongside quieter contemplation and intellectual play, there flourishes a strange mix of carnival novelty, barbaric transgressions of morals, and offences against systems of belief. Discussion of contemporary art, ranging from specialist journal to tabloid column, encompasses respectful exegesis, complex philosophical diversions, fawning publicity, and finally denunciation, ridicule, and dismissal. Yet this familiar scene—how old and how established is art's rule-breaking, and how routine are the recommendations and condemnations—masks significant recent change.

Some of this change has been driven by art's internal concerns, while some is a response to broader economic and political transformation. At first sight there seems to be no system against which art is currently more differentiated than the global neoliberal economy, founded on the ideal if not the practice of free trade. The economy functions strictly and instrumentally according to iron conventions, imposed unequally on nations by the great transnational economic bodies; it establishes hierarchies of wealth and power; it enforces on the vast majority of the world's inhabitants a timetabled and regulated working life, while consoling them with visions of cinematic and game-world lives given meaning through adventure and coherent narrative (in which heroes make their lives free precisely by breaking the rules), with 'reality' shows that stage and spin stories around social interactions and sporting events, and with plaintive songs of rebellion or love. This is the nerve pressed on by Jonathan Richman's deceptively saccharine song, *Government Center*, in which rock music helps the secretaries feel better as they go about their mundane and repetitive tasks.

The song ends with the dinging of a typewriter bell. The technology has changed, but it still tells its listeners what pop songs are (mostly) for.

Art appears to stand outside this realm of rigid instrumentality, bureaucratized life, and its complementary mass culture. That it can do so is due to art's peculiar economy, based on the manufacture of unique or rare artefacts, and its spurning of mechanical reproduction. When artists do work in reproducible media, their dealers artificially constrain the number of copies in circulation, with limited-edition books, photographs, and DVDs. Even purely digital work can be limited by being confined to a physical display system, and bound with a legal contract. This once small world—which when seen from the inside appeared autonomous, a micro-economy governed by the actions of a few

important collectors, dealers, critics, and curators—produced art's freedom from the market for mass culture. To state the obvious, Bill Viola's videos are not play-tested against target audiences in the Midwest, nor are producers forced on art bands like Owada to ensure that their sound will play inoffensively in shops or appeal to a core market of 11-year-old girls. So this cultural enclave is protected from vulgar commercial pressures, permitting free play with materials and symbols, along with the standardized breaking of convention and taboo.

The freedom of art is more than an ideal. If, despite the minuscule chance of success, becoming an artist is so popular, it is because it offers the prospect of labour that is apparently free of narrow specialization, allowing artists, like heroes in the movies, to endow work and life with their own meanings. Equally for the viewers of art, there is a corresponding freedom in appreciating the purposeless play of ideas, forms, and materials, not so much in slavishly attempting to divine artists' intentions, but in allowing the work to draw out thoughts and sensations that connect with their own experiences. The wealthy buy themselves participation in this free zone through ownership and patronage, and they are buying something genuinely valuable; the state ensures that a wider public has at least the opportunity to breathe for a while the scent of freedom that works of art emit.

Yet there are many reasons to wonder whether free trade and free art are as antithetical as they seem. The economy of art closely reflects the economy of finance capital. Donald Sassoon has explored patterns of import and export of novels, opera, and film in the 19th and 20th centuries. Culturally dominant states have abundant local production that meets the demands of their home markets, importing little and successfully exporting much. In the 19th century, France and Britain were the foremost literary powers. Since the end of World War II, the US has been by far the most dominant cultural state, exporting its products globally while importing very little. As Sassoon points out, this does not

mean that everyone consumes American culture, just that most of the culture that circulates across national boundaries is American.

Sassoon rules fine art out of his account on the sensible grounds that it has no mass market. It is hard to read trade figures for signs of cultural dominance in a system that is thoroughly cosmopolitan, so that you may have a Mexican collector buying through a British dealer the work of a Chinese artist resident in the US. We can, however, get an idea of the volume of trade in each nation, and, given the high proportion of international trade in the art market, this does give an indication of global hegemony. Here there are conspicuous parallels with the distribution of financial power.

As that power has shifted between nations, so has the art market. When this book was first published in 2006, the US was highly dominant, accounting for a little less than a half of all global art sales; Europe took much of the rest, with the UK taking as its share around a half of that. Since then, the scene has undergone rapid and often volatile change: first, the market for contemporary art has grown rapidly, at around 10 per cent a year, so that despite some dramatic fluctuations, it is now ten times larger. Second, there are periods at which China competes with the US for the largest market share (at least according to auction figures, which should be treated with some scepticism, as we shall see). Third, many entirely new markets for contemporary art have emerged in places as diverse as Azerbaijan, Brazil, India, and the Gulf states.

To raise this parallel with the economy is to see art not only as a zone of purposeless free play but as a minor speculative market in which art works are used for a variety of instrumental purposes, including investment, securing leveraged loans, tax avoidance, and money laundering. So as to banish such crude economic considerations from the minds of its viewers, contemporary art must continually display the signs of its freedom and distinction,

by marking off its products from those vulgarized by mass manufacture and mass appeal. It can make a virtue of obscurity or even boredom to the point that these become conventions in themselves. Its lack of sentimentality is a negative image of the off-the-shelf heroism, emoting, sweet fantasies and happy endings peddled in the vast majority of pop songs, cinema, and television. In its dark explorations of the human psyche, of which the worst is generally assumed, it appears to hold out no consolation. Yet, naturally, all of this ends up being somewhat consoling, for out of art's negativity quite another message emerges: that such a zone of freedom, and even critique, can be maintained by the instrumental system of capitalism.

Most dangerously for the ideal of unpolluted cultural freedom, it is possible to see free trade and free art not as opposing terms but rather as forming respectively a dominant system and its supplement. The supplement may appear to be an inessential extra but (in Jacques Derrida's celebrated analysis) nevertheless, like the afterword to a book or footnotes to an essay, has a role in its completion and shares its fundamental character. Free art has a disavowed affinity with free trade, and the supplementary minor practice is important to the operation of the major one. So the tireless shuffling and combining of tokens in contemporary art in its quest for novelty and provocation (to take some prominent examples, paint and elephant dung, boats and modernist sculpture, dye and dogs, a Pope and a meteor) closely reflect the arresting combinations of elements in advertising, and the two feed off each other incessantly. This relation has become more visible in recent years. Famous branded artists compete for attention by making spectacular and accessible works, meant to snag the minds of the public and the wallets of billionaires. Many works are designed to bawl their pitch across the crowded floor of the art fair. The pressures of social media bear down on all alike, as Instagrammable art steps to the fore, and art loses its virtuous opacity, progressively thinning, and letting shine through its reduced surfaces the glare of Capital.

As in the parade of products in mass culture, forms and signs are mixed and matched, as if every element of culture was an exchangeable token, as tradable as a dollar. The daring novelty of free art—in its continual breaking with conventions—is only a pale rendition of the continual evaporation of certainties produced by capital itself, which tears up resistance to the unrestricted flow across the globe of funds, data, products, and finally the bodies of millions of migrants. As Marx put it a century-and-a-half ago, in a passage of striking contemporary force:

> The bourgeoisie, by the rapid improvement of all instruments of production, by the immensely facilitated means of communication, draws all, even the most barbarian, nations into civilisation. The cheap prices of its commodities are the heavy artillery with which it batters down all Chinese walls, with which it forces the barbarians' intensely obstinate hatred of foreigners to capitulate. It compels all nations, on pain of extinction, to adopt the bourgeois mode of production; it compels them to introduce what it calls civilisation into their midst.... In one word, it creates a world after its own image.

It is not merely national barriers that are demolished. Continual innovation in manufacture and culture dissolves old structures, identities, traditions, and attachments, so that in Marx's famous phrase, 'All that is solid melts into air...'

Later, we shall see that there are many artists who critically examine the affinity between contemporary art and capital. Since the financial crisis of 2008, with its still unfolding depredations, that affinity has become the explicit focus of many artists' work. For many in this new scene, the old defences of art's autonomy lose much of their plausibility—but still they remain regularly intoned, powerful, and persistent. They run something like this: this work of art, this artist, or even the art scene as a whole transcends rational understanding, pitching the viewer into a state of trembling uncertainty in which all normal categories have

slipped away, opening a vertiginous window onto the infinite, some traumatic wound normally sutured by reason, or onto the void. According to this standard view, art works are only incidentally products that are made, purchased, and displayed, being centrally the airy vehicles of ideas and emotions, the sometimes stern, sometimes gentle taskmasters of self-realization.

In *The Rules of Art*, an exceptional analysis of French literature in the second half of the 19th century, Pierre Bourdieu traces the social conditions for the emergence of an autonomous art, free of the demands of religion, private patrons, and the state. He notes the survival of this belief—that art is inexplicable—born at that time, into the present:

> I would simply ask why so many critics, so many writers, so many philosophers take such satisfaction in professing that the experience of a work of art is ineffable, that it escapes by definition all rational understanding; why are they so eager to concede without a struggle the defeat of knowledge; and where does their irrepressible need to belittle rational understanding come from, this rage to affirm the irreducibility of the work of art, or, to use a more suitable word, its transcendence.

Today art is supposed to have passed into a different epoch, far removed from the first flush of avant-garde activity in the works of Flaubert and Courbet, and its evolving devotion to art for art's sake. The continued insistence on the unknowability of art is all the more strange because it is now accompanied by a prominent array of transparently instrumental art practices. Since we cannot know what we cannot know, this mantra about the impenetrability of the realm of art stands out as naked propaganda. The uses to which art is put, and the identity of those who use it, are often far from mysterious. Since the fall of Eastern European Communism and the emergence of capitalism as a truly global system—and further still since the crisis of 2008

onwards—these uses have become more widespread, transparent, and financialized.

Beyond the Cold War

The current face of the contemporary art world was forged in the global events of 1989 and after—the reunification of Germany, the disintegration of the Soviet Union, the rise of global trade agreements, the consolidation of trading blocs, and the transformation of China into a state-directed capitalist economy. Ever since the capital of the arts switched from Paris to New York following World War II, the art world had been structured by the Cold War division of East and West. The state-supported high art of each bloc was a negative image of the other: if the art of the East had to conform to a collectivist ideology and do its part to further the creation of Communism, then the art of the West had to be free of any such direction, and attain perfect uselessness. If the art of the East celebrated the achievements of humanity, and particularly of the socialist 'Man', then the art of the West had to focus on humanity's limits, failures, and cruelties (all the while holding out the hope that art itself, in its very excavation of these troubles, may be an achievement in itself). With the fading of this antagonism (slowly under *glasnost* and then swiftly as the regimes of the East imploded), and with the much-trumpeted triumph of capitalism (the establishment of a 'new world order' in which the US was the only superpower), the art world swiftly reconfigured itself. As we shall see, new art events peppered the globe, while artists of many nations, ethnicities, and cultures, long ignored in the West, were borne to critical and commercial success.

The shift was prepared for by postmodern critique, which, in a complex series of theoretical moves, affirmed what the market had slowly sanctioned, unveiling the white male 'genius' skulking behind the universalist façade of high culture. Feminists challenged the male dominance of the art world, doing much to reformulate the very standards of judgement that had assured

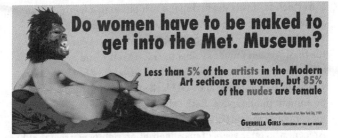

Do women have to be naked to get into the Met. Museum?

Less than 5% of the artists in the Modern Art sections are women, but 85% of the nudes are female

Statistics from the Metropolitan Museum of Art, New York City, 1989

GUERRILLA GIRLS CONSCIENCE OF THE ART WORLD

1. Guerrilla Girls, *Do Women Have To Be Naked To Get Into the Met. Museum?*, 1989.

women's exclusion. The Guerrilla Girls (Figure 1) effectively highlighted the extent to which women were excluded from the art museum—and continue to be, in shocking statistics, despite recent prominent acts of resistance and restitution. While in the decades since their 1980s work, feminist activists have made remarkable advances in the art world—registered in major exhibitions such as the Brooklyn Museum's *Global Feminisms* (2007) and in some very prominent events, such as Documenta XIII, in which gender parity was achieved—the figures as a whole remain far from equal. As we shall see, there are structural reasons behind this persistent bias.

The rise of the prominent multicultural exhibition exactly coincides with the end of the Cold War, with two major shows, planned in the years of *glasnost*, breaking the institutional white monopoly in Paris and London: the Pompidou's *Magiciens de la Terre*, and the Hayward Gallery's *The Other Story*, both of 1989. Each was controversial and, as first forays into this area, necessarily partial. *Magiciens de la Terre*, curated by Jean-Hubert Martin, was criticized for exoticizing what were then called Third World artists, an attitude expressed in its very title. No Third World artist was permitted to be modern, and instead ritual practices and objects were dragooned into a display fixed upon the artist's individuality and the autonomy of the art object.

9

Nevertheless, it was the first major exhibition in a metropolitan art-world centre to show contemporary First World and Third World art together on an equal footing. Artist and curator Rasheed Araeen fought against the indifference and condescension of the British art elite to produce *The Other Story*, which for the first time showed black and Asian British artists in a prominent public space. Both exhibitions achieved a new visibility for contemporary artists of colour. And both—despite the fears of Araeen, who after years of marginalization rightly worried that his show might be no more than an isolated 'curiosity' in the continuing white-out—proved to be heralds of a system under which non-white artists would no longer need to complain of invisibility, and were faced instead with worries about the type of attention they were receiving.

Following the end of the Cold War and up until the 2008 crisis, the global consolidation of an unrestrained type of capitalism, dubbed 'neoliberalism', also coincided with this flush of colour to the art world's cheeks. Under neoliberalism, the language of free trade is insistently recited but the global regulatory bodies (the World Bank, the International Monetary Fund (IMF), and the World Trade Organisation (WTO)) enforce rules that protect industries and agriculture in wealthy nations while opening fragile economies to unregulated trade, privatization, and the dismantling of welfare provision. The familiar results across the globe are low wages, insecure employment, high unemployment, and the weakening of unions. This system, and its catastrophic consequences for the weakest nations, has been plotted by ex-World Bank economist, Joseph Stiglitz, who has shown, for example, how the IMF and the World Bank produced or exacerbated crises in Russia, East Asia, and elsewhere with grave and frequently lethal results for their inhabitants. Inequality has been simultaneously weakening between nations as it becomes easier to move around production to exploit low wages, weak or non-existent unions, and lax regulations, and increasing within nations as the super-rich grabbed virtually all of the proceeds.

Yet, despite the wealth that flows to transnational corporations and the super-rich—and as a result into the art world—the greatest effect on art of the 1990s was not on its economy but its rhetoric. A loud chorus of voices was heard praising the demolition of cultural barriers that accompanied the supposed destruction of barriers to trade, and the glorious cultural mixing that resulted. In this, the art world was hardly alone, for a wave of enthusiasm for globalization swept through the discourses of economics and politics, along with the humanities, from academic conference to liberal newspaper, and it is only since 2008 that the voices against have obtained prominence and even power. This intellectual tradition had radical roots, in the writings of Aimé Césaire, Fernando Ortiz, Stuart Hall, and others, especially in thinking out the cultural characteristics of the African diaspora, in slavery and colonialism, and the syncretic mixing that was forced on diverse slaves and migrants as they were forcibly thrown together, and how they evolved cultures of resistance and survival. For Hall, in particular, while acknowledging the power of dominant ideologies, migration was seen as a disruptive and positive force, interfering with the settled business of governance, national borders, and prejudicial law, the false universalism and coherence of which were challenged by fractured, fragmented, and multiple identities.

While the art world has taken up the politically liberal aspect of this tradition, in particular recommending the benefits of cultural mixing or hybridity, the overall vision behind it—of eroding hierarchies as a rich and various culture of the oppressed displaced the rigidities of fixed identities and national attachments—was heard more softly. It could hardly be otherwise, since this new diversity was ushered into a system that remained constitutionally individualistic and hierarchical. Throughout the 1990s and beyond, biennials and other art events were founded across the globe, while cities built new museums of contemporary art, or expanded old ones. The activities of these museums became steadily more commercial as they adopted corporate ideals,

11

established alliances with business, brought their products closer to consumer culture, and modelled themselves less on libraries than on branded shops and theme parks. At the same time, contemporary art moved into closer contact with selected elements of a mass culture that are so pervasive that this turn is sometimes confused with an engagement with the 'real' or 'real life'. Art stars have long been celebrities, but now the art scene as a whole is treated much like fashion or pop, and even its minor players appear in those parts of the media that devotedly track the orbits of the celestial bodies. In particular, art and fashion have increasingly been seen hand-in-hand, as the cult of youth that has enveloped culture as a whole also saturated the art world.

Culture Wars

The erosion of straight, white, male dominance was hardly a serene progression towards greater inclusion and social justice. In what now read as overt displays of ignorance and condescension, a cabal of conservative critics, including Andrew Graham-Dixon and Brian Sewell, had done their best to put the artists of Araeen's *The Other Story* back in their 'proper place' by dismissing their work as marginal, derivative, and second-rate. In the US, contemporary art, particularly photography and performance, were at the centre of a political battle over central government funding of the arts. It was sparked by the showing in state-subsidized venues of works which could be read as obscene or blasphemous. In 1989, before his fellow senators, Alphonse d'Amato tore up a reproduction of Andres Serrano's *Piss Christ*, a photograph of a mass-produced crucifix immersed in the artist's urine. In 1990, for exhibiting Robert Mapplethorpe's exhibition, *The Perfect Moment*, Dennis Barrie, director of the Cincinnati Contemporary Arts Center, found himself in the dock on charges of violating obscenity laws. The show had included depictions, in Mapplethorpe's highly aestheticized black-and-white photographs, of gay sex, sadomasochism, and the results of the artist's long quest for the perfect (black) dick. Barrie was

acquitted, though the defence was reduced to arguing that the photographs were art, and not pornography, because they could be enjoyed formally. In the same year, Congress refused to provide funding for Judy Chicago's signal feminist work, *The Dinner Party*, to be acquired by the University of the District of Columbia on the grounds that it was '3-D ceramic pornography'. These works and others were used as the basis for a Republican attack on the National Endowment for the Arts (NEA), the federal source of arts funding in the US. The attack was partly successful, substantially reducing the already modest sum at the NEA's disposal and, despite furious political controversy, for a time cowing opposition and contributing towards producing a more quiescent scene. As Douglas Davis pointed out in a fine and detailed account of the Clinton administration's record on the arts, its strategy in the face of continued conservative attacks was defensive and limited, and offered no positive alternative vision for the visual arts. The result was further politically motivated cutting of the NEA budget.

Conservative anger was directed at depictions and performances that celebrated gay sexuality, or objected to government inaction over AIDS, or openly displayed sexualized black bodies. While such works were openly reviled, with a rage that laid bare the racism and homophobia of much of the US political landscape, the attack also extended to political art as such, and particularly to works that examined racism. In 1994, the Whitney's *Black Male* exhibition, curated by Thelma Golden, was the subject of particular controversy, due to its many depictions of naked bodies in an explicitly political show that took on the white establishment's fear and subjection of black men. One piece that tellingly condensed the concerns of the show was Mel Chin's *Night Rap* (Figure 2), a police nightstick, the side-handle of which was shaped into an erect penis. It still resonates today as Black Lives Matter highlight police slaughter of people on racial lines, and as the US *gulag* holds over two million prisoners, a large proportion of them black.

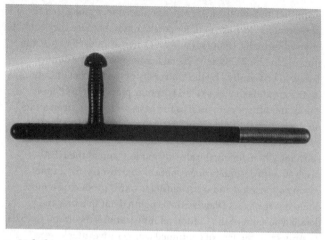

2. Mel Chin, *Night Rap*, 1993.

Black Male met with objections not only from white conservatives uncomfortable with the political resonance of the subject but from black activists and artists who criticized its concentration on the nude, and thus the possible confirmation of the very attitudes it set out to criticize.

Explicitly political art gained prominent display in the US in the early 1990s, and was greeted with strident objections, even from moderately conservative critics, such as Peter Schjeldahl and Robert Hughes, who made a concerted attempt to have such work ruled out of the category of 'art'. Yet how did politicized art, long made by activists struggling against the mainstream, but little seen, come to such prominence?

Desperate and even deadly struggles for recognition and rights were one basis—for gender and racial equality, and for campaigns to fight state indifference to the AIDS crisis, in which many artists, such as the collective Gran Fury, played a prominent role. In part it was a reaction against the market-friendly art of the

1980s which had been so suddenly beached and stranded by the recession of 1989 onwards, and an anticipation of a liberal turn in politics, for many in the art world actively backed Clinton in 1992. There was further a structural reconfiguration of US art in the face of the newly globalized art world. If the establishment of New York as the centre of the art world following World War II had meant a shift in the focus of American art from local and national concerns to supposedly universal themes, the new order required the abandonment of universality in favour of an exploration of diversity, difference, and hybridity. At first, the physical centre of the art world remained right where it was for, as the world's most multicultural nation, the US had this advantage under the new system to add to its economic and political might. Yet it could not exercise that advantage until its own prejudices and exclusions—barriers to trade—had been confronted. The 'Culture Wars' and the battle over political art that followed were a modernizing process. They were to be replayed elsewhere many times, especially in nations where religion held a prominent place in politics and public life, with similar scandals over abused religious symbols and explicit sexual scenes and issues causing censorship and the sacking of curators in Russia, Poland, Greece, India, and Dubai.

If the prominence of this political art was comparatively brief, this was partly because it had served its purpose: art did diversify and, once it had adapted itself to its new circumstances, could not go back. Serge Guilbaut has shown how the regionalism and nationalism—the particular local concerns—of the US art world had to fall away as it moved to establish global dominance through an art that was simultaneously American and 'universal'. In a further stage, that dominance is sublated, so that it no longer requires that art be American, only that it be made according to the US model of global neoliberalism. If this politicized art failed to fulfil its own wider radical ideals, it was due to its isolation from political movements. Benjamin Buchloh, in a mordant but compelling account of contemporary art, argues that the long

trend in the US (and, one may add, elsewhere) for politics to move
from the public to the private realms was reflected in an art that
focused on artists' identities and the way these could be constructed
through assemblages of conventional signs. At least until the 'war
on terror' that followed the events of 9/11, and the 2008 crisis,
it was more comfortable to explore these concerns than the
intractable issues of social class and indifferent political institutions.

The identities formed by money and class, and their integral links
to the making of other identities, were vitiated in this politics. So
when the US economy revived, especially through the mid-1990s,
a mutated market-friendly work once again came to the fore, in
which identities became spectral associations, their blending and
wafting this way and that being the subject of consumerist whim.
One prominent exemplar is the highly successful work of Kara
Walker whose cut-out fantasy scenes of sex and violence down on
the plantation generated much controversy (Figure 3).

Identity at its most traumatic—the utter humiliation of slavery—is
seen in silhouette as caricatured figures act out the grossest acts of
subjugation, rendered in a sweet, fairytale manner. As Coco Fusco
points out, there is no clear moral frame of reference here, and the
work does not document or preach but appeals to suppressed
fantasy and desire. The question is, *whose* desires? Some black
commentators, notably Betye Saar, were deeply uncomfortable
with Walker's sudden and dramatic success in the mainstream art
institutions, seeing the work as amusing a white audience with a
dangerous confirmation of their own prejudices. She campaigned
unsuccessfully to get Walker's work banned from public view.

As Walker's work has developed, however, she has leveraged
its success to produce counter-monuments of vast size and
presence. In a disused and soon to be demolished sugar factory
in Williamstown, Walker made a gargantuan white sugar
sphinx in the form of a clichéd black 'mammy', though with

3. Kara Walker, *Camptown Ladies* (detail), 1998.

extravagantly prominent and explicitly modelled genitalia.
The largest single piece of public art erected in New York City,
it had an outsized title:

> At the behest of Creative Time Kara E. Walker has confected: A
> Subtlety or the Marvelous Sugar Baby an Homage to the unpaid
> and overworked Artisans who have refined our Sweet tastes from
> the cane fields to the Kitchens of the New World on the Occasion of
> the demolition of the Domino Sugar Refining Plant.

As with much of Walker's work, this presented a number of
conundrums without apparent answer (this was a Sphinx, after
all): black and white, of course, labour and commodity, slavery
and sweetness, a 'subtlety' (traditionally, a sugar sculpture) and
sexuality. Hundreds of thousands of people came to see this work,
which made its artist a celebrity.

While Walker remains a self-confessed trickster, without overt political commitment, *A Subtlety* is a register of the way in which black issues and histories have moved close to the mainstream of the art world, and not just in the US, where one can point to very prominent and commercially successful work by artists such as Mark Bradford, David Hammons, Theaster Gates, Glenn Ligon, Lorna Simpson, and Julie Mehretu. Among the prominent writers who have pointed to this change in the cultural temperature, Ta-Neshisi Coates puts the matter well when he says that he realized that writing about black issues had moved from marginal to central: 'I was not reporting from some corner of American society but from the very heart of it, from the plunder that was essential to it and the culture that animated it.' As the Black Lives Matter movement has made clear, the history of capitalism and slavery is entwined with contemporary injustice in a battle over wealth (reparations) and cultural memory (monuments).

The remaking of installation art

Another signal change in 1990s art was the rise of 'installation art'. This is a complex and contested term, but a basic definition is that installation art has no frame and is not viewed from a distance; rather, the viewer inhabits it and moves around inside it. It had once been seen as an art that firmly resisted buying and selling, being by definition ephemeral and difficult or impossible to move around. So, as Julie H. Reiss has it, installation came in two distinct waves: it was born in the 1960s, and then revived from its long slumber through the commercially driven years of the 1980s. In its first life (then known as 'environment' art) it had been shown in newly founded 'alternative' and often artist-run spaces. Installation's renewed popularity coincided with the recession of 1989, but in its reawakened form it established itself at the heart of the art world, in museums. The change in name from 'environment' to 'installation' was significant, for exhibitions are installed. Installation no longer necessarily resists

commodification, since it is now often moved and paid for. Even when it is not, installation is regularly used by artists and dealers as a loss-leader for more marketable products.

Installation is not medium-specific or itself a medium. It may encompass video and older media like painting, and may be seen as a spatial art in which all media—even elements of performance—are subsumed. It did not go unopposed, particularly from those who had long associated thinking about the singular medium with critical art. Rosalind Krauss, to take a prominent example, thought that such inhabited hybrids tend to powerlessly and uncritically mimic the general leaching out of aesthetics into the social and commercial field: only a few worthy artists successfully resist this move, by making work that brings media together without losing sight of the contested histories of each one, and their continuing dialectical tensions.

Installation has two marked advantages over the framed work. The first is in the continuing competition with mass culture—how to persuade an audience to travel to a museum or other site rather than watch television, play games, go shopping or to the movies, a concert, or a football match. There has been an intensification of competition here, a vying for spectacle, with television, to take a signal example, transforming itself with large, wide screens, high definition, and downloading. We have seen that art sets itself off from mass culture by its handling of content. Aside from that, what the reproducible media cannot yet simulate is the feeling of a body moving through a particular space surrounded by huge video projections or work that has weight, fragrance, vibration, or temperature. So installation, which allows a space to be inhabited rather than merely presenting a work of art to be looked at, comes to the fore.

The second advantage is that the exclusive commissioning of a work for a particular site is a way of ensuring that viewers have to

go there, and collections of such works by important artists clustered in a biennial are powerful magnets for art-world attention. In this way, installation and site-specificity are linked to the globalization of the art world, and an art used for regional or urban development. Since this is now the regular strategy, being there—not only in Venice, Basel, and Madrid but now in São Paulo, Dakar, Istanbul, Sharjah, Singapore, or Shanghai—has become another way to confirm social distinction on the viewer (as only slight exposure to art-world chatter, so often fluttering about the latest exotic jamboree, will confirm).

In later chapters the links between these various elements of art since 1989 will be explored: the US Culture Wars may be seen as a domestic prelude to the wider issues of global hybridity, and were constituted by the same disposition of forces: on one side, liberal consumerism committed to the demolition of restraints on commerce in the broadest sense; on the other, the local forces of tradition, religion, and moral deportment. Installation is associated with spectacle and competition with the mass media. Contemporary installation is expensive and is generally reliant on private sponsorship and public funding. It is thus tied to corporate involvement in the arts and the commercialization of the museum, in a way that directly cuts against its origins in do-it-yourself artists' projects; this in turn is linked to the connection between globalization and privatization which pushes museums and galleries into competing to produce ever more spectacular displays. Similarly, the symbiosis with mass culture, and the urge to engage with 'real life' (often seen through consumer culture and the concerns of the mass media) are part of the same impetus.

Boom and bust

Since the art world is bound to the economy as tightly as Ahab to the white whale, another way of looking at their relationship is through the economic cycle. Painting, the most easily saleable

form of art, undergoes a predictable revival with each boom, while less straightforwardly commercial practices—including performance and the various strands of post-conceptual art—step out into prominence with each bust. This oscillation is played out in a continuing apparent struggle between the market and apparently unmarketable forms (credibility in eschewing overtly market-friendly forms may eventually lead to a price advantage). It is a predictable and mechanical process. So, to take one example, economic revival in the US in the mid-1990s produced a concerted attack on the political art of the previous years, and a sustained attempt to rehabilitate beauty in art, and to establish the voice of the market as the final arbiter of taste (led prominently by the critic, Dave Hickey).

The period under discussion here—from 1989 to the present day (I write as various right-wing populist governments threaten the internationalist global order)—is bounded on either side by recession. The first was the spectacular crash of 1989 that slaughtered the bloated artistic giants of the 1980s glut, shattering art-world self-importance and confidence, and in the longer term producing ruder and more accessible work, alongside politically committed art. The second, of 2008 onwards, while it has affected the commercial art world less, constitutes a deep and ongoing crisis for the entire system of global capital.

The first recession, the headlong crash of the 1980s boom, put paid to the vast (and vastly expensive) quasi-historical and neo-expressionist paintings by Anselm Keifer or Julian Schnabel that had been the perfect register of the decade's excess and bombast. They plunged in value, and swiftly disappeared from the salerooms (along with quite a few of the salerooms). Their reintroduction to the market some years later was so sensitive a matter that a critic I know wrote a catalogue essay on one of those giants for a commercial gallery with the dealer literally standing at his shoulder.

Developments in Japan were important to the speed and depth of the recession in the art market, particularly because of the scale of Japanese buying throughout the 1980s, itself buoyed by apparently rampant and unstoppable growth in share and real-estate prices. Peter Watson provides a detailed account of the scheme under which works of art were used to launder huge slush funds to benefit corrupt politicians and organized crime: government curbs on profiting from real estate were evaded by sellers 'buying' a painting on the understanding that it would soon be bought back from them at perhaps ten times the original price. The most damaging aspect here was not merely that secret deals were being made or tax evaded—standard characteristics of the art world—but that the scam distorted the market. Suddenly it seemed that the Japanese penchant for paying huge amounts of money for undistinguished impressionist and post-impressionist paintings was less to do with naivety of taste than unscrupulous calculation. The breaking of the scandal had a depressing effect on the market, which was further shaken by prominent Japanese bankruptcies and the threat that large numbers of works bought at the height of the boom might be suddenly offloaded, further lowering prices. When some of the works involved in the scam were sold off in 1993, it was at a tiny fraction (under 1 per cent) of the prices originally paid.

Recovery from the fall of 1989 took several years, and many wondered whether the market would ever regain the heights of the 1980s boom. Another global recession from 2000 onwards was a slower-burning affair in the West, caused by the failure of the high-tech sector, and followed by general falls in the stock market, scandals over financial corruption, and then war. As it grew, the 1990s bubble of stock market growth, associated especially with high-tech industries, had an inflationary effect on art prices. Record sums were achieved at auction throughout the late 1990s. When the bubble burst once more—following the dotcom share price collapse, accounting scandals (including that involving Enron), and the events of 9/11—the art market and

museums sector also went into decline, though the slump was shorter and less sharply felt than in the previous recession. The art market was more robust this time around because it was more globalized than the downturn. The growth of new markets in Russia, China, and elsewhere offset the doldrums in Western Europe and the US. The digitization of art sales' data, and the evolution of various models for mapping, comparing, and analysing prices allowed for the more systematic use of art collecting as hedges in investment portfolios.

In the following years, the revival of the contemporary art market was rapid and from 2003 saw precipitate growth. As in the rest of the economy, the distribution was highly unequal. While the overwhelming majority of artists remained poor, increasingly vast sums were paid for works by famous branded artists: in a telling incident in 2004, the fittings and furnishings from Hirst's restaurant, Pharmacy, were sold for £11 million at Sotheby's, over three times the auction house's estimate, with even the toilet paper making £15,000.

Yet, despite the deluge of boosterish propaganda, which vaunted the power of unfettered capitalism, the entire period had been marked by a series of increasingly deep and threatening regional financial crises in Mexico (1994), Southeast Asia (1997), Russia (1998), and Argentina (2002), which some saw as harbingers of serious, system-wide trouble. The global crisis unfolded in 2008, to the bewildered astonishment of those who had swallowed the neoliberal potion. It was a crisis particularly of the old, rich states—of Europe and the US—in which its effects are still felt. If the offering of a loan, the effective creation of money, is a bet on future growth, the 2008 crisis was a failure in the belief that public and private debt could ever be paid back, given the lacklustre growth rates of those economies, and given the fantastically complex bundles into which diverse debts had been sold and resold, making it impossible to judge their value. It left many states in a weakened situation, having scant

resources with which to deal with the next financial storm, which has now arrived.

The effect on the art world was profound, though it was largely to reinforce elements already in play. Again, the decline in turnover and prices was short-lived because the market was global, and increasingly driven by complex investment bets to spread risk. Given the weakening of the neoliberal states, and the precipitate rise in art prices, museums came to have little say in the market, which is held in thrall by a fairly small group of ultra-rich collectors. These were further enriched by governments' response to the crisis—mostly to print money and hand it to the banks (in a process known as 'quantitative easing'), which vastly increased asset prices, including those of art. The art world, already highly unequal, became more so. Just as the crisis extended insecurity from the working class to the middle class, so those galleries with modest businesses serving the merely wealthy found themselves in trouble. The few global mega-brand auction houses (led by Sotheby's and Christie's) and galleries (White Cube, Gagosian, Hauser, and Wirth) and their branded artists soared to new heights. As a result, the art world became profoundly split between those galleries, art fairs, and artists that served the billionaires, and those trying to make a living elsewhere. As we shall see, some artists turned to making dissident work in explicit opposition to luxury taste.

Beyond these waves and troughs, the entire period is a phase of financialization, in which productive investments are hard to come by, economic growth slows, financial speculation grows to compensate, and the price of assets rise. As Giovanni Arrighi has shown, since the late 15th century, capitalism has regularly undergone such phases, each shorter than the last, and more destabilizing. Each is characterized by lavish spending on war and luxuries, including art. The current economic crisis, deeper and more durable than the others, may spell the end of this phase.

In the chapters that follow, on globalization, the relation with consumerism, the cost and uses of art, and the characteristics of art, these widening tensions will be analysed. They have reached a point at which the entire edifice of what we call 'contemporary art', like the ancient Venetian palazzi in which it is regularly displayed, is cracked and listing.

Chapter 2
New world order

Doris Salcedo is a Colombian artist who makes sculptures out of furniture that once belonged to people who have 'disappeared' in her country's long civil war. In this bitter struggle, both sides—guerrillas and government—funded the war by drug-dealing, while the Colombian army, despite their long record of human rights abuses, was lavishly funded by the US. Paramilitaries closely allied with government forces abducted and murdered people with impunity. In some of Salcedo's works, one piece of furniture is carefully placed inside another in a coupling. In others, what looks at first sight like the grain of wood turns out to be human hair. These assemblages are blocked up with cement, which also sometimes partially submerges a door or an upturned table. In looking at these pieces there is a feeling of extremely slow submersion or erosion, a graph of the action of memory, seared by violence into the mind, sealed up by silence and censorship, returning unwanted in dreams and involuntary thoughts; and equally painfully losing its precise definition as time passes, and new memories, and memories of memories, are laid over old.

Giles Gilbert Scott's Anglican Cathedral in Liverpool is a vast, bare Gothic building, conventional in grandeur and architectural layout but built through the course of the last century. To walk within it is to feel a strong sense of the uncanny. Where are the

trappings of historical memory, the signs of their erasure and ageing, the familiar clutter of centuries? It is rather that an ancient cathedral was newly minted, and left naked.

The first Liverpool Biennial of Contemporary Art, held in 1999, included an international component, *Trace*, curated by Anthony Bond, which placed pieces of contemporary art in various locations around the city. Salcedo's work appeared in the Anglican Cathedral. What did this combination amount to? The seventy years of the cathedral's construction spanned two world wars, the rise and suppression of political radicalism in Britain, deindustrialization, and the sweeping secularization of that society, so that the completed building was born outsized into a city drained of work, population, and faith. Salcedo's works, a meticulous and laborious attempt to honour memory, are a visual counterpart to Eduardo Galeano's extraordinary writings, which recover collective, political memory in the face of the violent attempts to repress it throughout much of Latin America. More specifically, as Charles Merewether points out, they speak against the freezing of memory that disappearance is designed to produce, for the mourners lack a body, a grave, and even the certainty that their loved one is dead. Visually, Salcedo's works suited the gigantic spaces of the cathedral, her cabinets appearing as mutated confessionals or oversized coffins. Site and work in such juxtapositions are meant to combine to enrich each other, productively bringing cultures together, provoking thought, and granting insight to other histories and cultures. Although it is fitting to place gravestones in a cathedral, here the combination seemed antithetical, since Salcedo's ritual forms of memory worked against the mute ghost of Anglicanism, in a building that had been erected as if nothing had changed.

Trace is a typical biennial title: vague enough to include almost anything, and at the same time evoking the revivification of lost or repressed events, people, and cultures. Liverpool is highly suited

for such an event: a city of docks, its once great wealth based on trade, including slavery, serving as an apt setting for art that reflected on globalization and its histories. While its centre has now been remade into a polished and conventional shopping precinct, then its down-at-heel urban fabric had plenty of large vacant spaces for displaying art, and even now its run-down areas, snags for romantic imaginings, are ripe for the gentrification that the biennial has helped to bring about. In 1999, all this set up some productive and provocative opportunities for the display of art including Vik Muniz's *Aftermath* (Figure 4) series in which he made poignant and complex work about the street children of his native city, São Paulo. Giving them reproductions of paintings by Van Dyck, El Greco, and Velázquez, and getting them to act out the poses, he photographs them. The photos are then used as the basis for elaborate images made up of refuse and confetti, the kind left on the street after Carnival has passed, out of which sketchy images of the children appear, spectrally traced in sugar. These are then photographed and displayed as large, fine prints in the gallery. Seen at the Tate, which bears the name of a sugar baron, the work referred to colonialism and slavery, and their continuing legacies into the present.

The foreword to the *Trace* catalogue claims that the Biennial reflects the city's 'current urban renaissance', though in 1999, this was more an aspiration than a statement of fact. The scattering of art exhibits around the city, wrote Bond, 'ensures that visitors will discover the rich character of Liverpool as they experience the art'. So the link to tourism was made explicit, and indeed the experience of the Biennial for visitors to the city was that of moving from place to place as a tourist, constantly referring to maps. There was a bewildering concatenation of works and places, and a lack of contextual material for both. Given that the event's principles were vague at best, the experience became primarily an aesthetic exercise in seeing work against an architectural setting, except for exceptionally well-informed art-world insiders (for whom, perhaps, it was primarily made).

4. Vik Muniz, *Aftermath (Angélica)*, 1998.

The catalogue lists the Biennial's sponsors and contributing organizations, which included business, local academic institutions and art boards, national arts councils, and state bodies promoting culture abroad, such as the Goethe Institute. This mix was telling of the kind of alliances that a biennial produces: businesses, large and small, wanting to boost their brand recognition; nations pushing their cultural products; regional bodies hoping for regeneration; and universities wanting to raise their research ratings. Only occasionally is this expressed with complete openness, as when the roving Manifesta biennial went to Murcia, a deprived area of Spain, leading its culture and tourism minister to write that the region 'instantly becomes part of the privileged system of promotion and diffusion provided by the prestigious "Manifesta branding".'

The Liverpool Biennial is merely one example of an increasingly widespread phenomenon. While the art world has long been cosmopolitan, the end of the Cold War, as we have seen, brought about a considerable retooling of its practices and habits. Just as business executives circled the earth in search of new markets, so a breed of nomadic global curators began to do the same, shuttling from one biennial or transnational art event to another, from São Paulo to Venice to Sydney and Havana. Since trade routes are an easy way to evoke a long history of connection in the light of globalization, many of these events take place in port cities.

Of those events in developing and communist states, some were long-established like the São Paulo Biennial (founded in 1951), or the Havana Biennial (1984)—a signal event because of its early attempt to foster artistic dialogues between nations in the global South. Many were entirely new, and from the mid-1990s, the number rocketed. Here are some of the new arrivals along with their starting dates: Istanbul (1987), Sharjah Biennial, United Arab Emirates (1993), Gwangju, South Korea (1995), Johannesburg Biennale (1995), Shanghai Biennale (1996), Mercosur Biennial held at Porto Alegre, Brazil (1997), DAK'ART,

Senegal (1998), Busan Biennale, Korea (1998), Berlin Biennale (1998), Yokohama Triennale (2001), and Prague (2003), Moscow (2005), Prospect New Orleans (2008), Kochi-Muziris (2010), Riga (2016), and Karachi (2017). The growth of these events has been rapid with more and more being founded with each passing year. There are now over 300 on five continents, though very unequally distributed, and there does seem to be a slowing of new biennials in areas (such as Europe) already saturated with them.

The general art-world view of this development is sanguine: the linear, singular, white, and patriarchal principles of modernism have finally fallen, to be replaced by a multiple, diverse, rainbow-hued, fractally complex proliferation of practices and discourses. Rosa Martínez, one such international curator, replies to the question 'what makes a biennial?' that 'The ideal biennial is a profoundly political and spiritual event. It contemplates the present with a desire to transform it. As Arthur Danto says, in a definition I love, a biennial "is a glimpse of a transnational utopia".' In each event, ideally, the point is to bring about an exchange of the blue-chip standards of globalized art—and to look at the biennial rosters is to see how many of the same names insistently recur—into productive contact with local artists and circumstances. Ideally again, this should in time produce a hybrid diversity of art forms produced by people of widely differing backgrounds and attachments that will speak both globally and locally, inhabiting and producing in-between spaces that undermine the homogeneous blocs—above all, the nation-state—on which power relies.

It is an ideal that has powerful (though not uncritical) theoretical backing—in particular, in writings by Homi Bhabha, Stuart Hall, Kobena Mercer, and Gayatri Spivak—regularly aired at the art events and in their accompanying literature, and it has helped produce the rise of artists from nations that had previously achieved such success only in exceptional cases. These artists, from China, Brazil, Russia, South Africa, Lebanon, or South Korea, for example,

do bring to the global art world new voices, perspectives, ideas, and styles. The intensity of Salcedo's work, which comes out of her collaboration with grieving relatives of the disappeared, is a world away from the second-hand, media-inspired fantasies of violence in the work of, say, Damien Hirst or Jake and Dinos Chapman, and the comparison makes them look shallow and foolish. Such work, which brings striking new concerns, perspectives, and ways of working into the art world, has been at the forefront on the circuit of international biennials. *Third Text*, a journal devoted to fostering and analysing Third World perspectives on art and culture, has had to shift its primary purpose from making such art and opinion visible to exploring the conditions of its remarkable success. As Jean Fisher puts it, the key problem is no longer invisibility but rather an excess visibility that comes about because cultural difference is now so readily marketable.

We can get an idea of the terms of this success by looking in turn at the biennials, some contrasting cases of art made in various regions, and then at the function and effect of this new ferment of globalized art production and consumption. The extraordinary proliferation of biennials is driven by the same forces that have caused new museums to spring up like mushrooms, and old ones to expand and rebuild. Governments are well aware that cities increasingly compete globally against one another for investment, the location of company headquarters, and tourism. The most successful cities must secure, along with economic dynamism, a wide variety of cultural and sporting fixtures. The biennial is merely one arrow in any would-be global city's quiver—or, as often, in one that aspires to that status—drawing in a cultured class of tourist (some of them extremely wealthy) and hopefully entertaining those privileged residents who have the power to leave.

A statement by influential global curator, Hou Hanrou, who has assembled a series of shows exploring rapidly growing Asian cities, puts the art-world interest clearly:

These new global cities represent the erection of new economic, cultural, and even political powers which are bringing about a new world order and new visions for the planet. What is the most important thing is that with their own specific legacies, these cities become new and original spaces in which new visions and understandings of Modernity, and new possibilities of 'Utopian/dystopian' imagination, can be elaborated and reinvented.

Such shows are, then, a cultural elaboration of new economic and political powers. The Havana Biennial serves to give the Cuban government a more lenient and culturally open-minded image by sanctioning dissent within a narrow frame. The Gwangju Biennial in South Korea, founded in 1995, was meant to mark the transition from Cold War dictatorship to democracy, in the very city where thousands of pro-democracy demonstrators had been massacred and tortured. The Sharjah Biennial was founded as an early part of a concerted effort to court global attention, stimulate tourism, diversify the economy, and to transform the standard outsider view of the culture of oil-rich Arab monarchies. The precipitate growth of biennials is an indication of the model's success, as increasing numbers of cities and regions compete for international attention by staging ever larger and more spectacular exhibitions.

The biennial has two further benefits for its host city that mark it out from a fair of new technology or an important football match. First, despite all the academic nay-saying from critics and theorists, in the public and civic eye, art retains a kudos that transcends ordinary culture and entertainment, and gestures towards the universal. As such, it performs the same function for a city—with all its crude jostling for position in the global market— as a Picasso above the fireplace does for a tobacco executive. Second, it not only embodies but actively propagandizes the virtues of globalization.

There are, though, circumstances in which the uses of biennials come up against the ideals they are supposed to embody. The Johannesburg Biennale was established in 1995, not long after the first free elections were held in South Africa in 1994. The idea was to reconnect South Africa with the cultural world after years of boycott. For the first Biennale a large and very diverse series of exhibitions was mounted in an attempt to portray Johannesburg as a fully formed global city. Local artists who might have presented a troubled view of the nation were generally excluded, and many thought that the Biennale presented a dubiously positive picture of South African society. While the Biennale was staged by two South African curators, Lorna Ferguson and Christopher Till, it was much criticized by locals for being an alien incursion into an otherwise deprived and divided region that was in no way ready for it, and for downplaying local art in favour of international attention. Thomas McEvilley, among others, was astonished to see that the event had apparently been boycotted by much of the black community, repulsed by the sycophantic courting of the international art world.

In 1997, the second Biennale—curated by Okwui Enwezor and an international team on the theme *Trade Routes: History and Geography*—attempted to respond to the critique of the first, by dealing with issues of race, colonization, and migration in a South–South dialogue. Again, it was a thoroughly globalist endeavour, containing shows by curators such as Hou Hanrou, Yu Yeon Kim, and Gerardo Mosquera. Despite the change in subject-matter, and the rigorously theorized curation, in such a setting the very form of the Biennale seemed to work against its success. The financial crisis of Johannesburg city council threatened and delayed the event. Again, local artists and critics complained that African production was sidelined in favour of a cosmopolitan concern with global hybridity, and that they were particularly disadvantaged by the attention devoted to media art in which few local artists had expertise, or the opportunity to acquire it. Worse still, some thought that the standard forms of

post-conceptual art and lens-based art had been foisted on the local culture in a neo-colonial manner, the result being inaccessible to local audiences and remote from their concerns.

This perception was reinforced by the lack of advertising and education funds, due to the city's cash crisis. Foreign visitors to the Biennale felt shut in, given the dangers of the city outside, so in neither direction did the cultural exchange flow as intended. As Charles Green and Anthony Gardner put it in their book on biennials, Enwezor's event was rejected by the political right because of its expense, and the left because of its exclusive internationalism. Furthermore, the pact with the West, which had brought about the end of apartheid, was purchased with a pledge to handle the economy in conformity with the usual global strictures and so condemn the vast majority of the black population to continued poverty. It could not be celebrated without ambivalence. The Biennale attracted far fewer visitors than expected, and was closed down by the city council a month early. The city then announced it had no more funds for another, and indeed South Africa would have to wait over two decades for its next international biennial.

Even successful events involve similar tensions. In Havana the Biennial has drawn large audiences to its displays of art from the South, and was at first concerned to engage locals with displays that highlighted dialogue between the art of developing nations, in a conscious and radical riposte to the dominance of the global art world by the US and Western Europe. But as the Cuban economy fell into deep crisis following the collapse of the Soviet Union (its major buyer of sugar), the character of the Biennial changed and became increasingly directed at foreigners. Its roster of artists became weighted towards the usual global art stars, so as to draw in dealers and well-heeled tourists. Its recent editions have sometimes inadvertently illustrated the tensions between the impoverished locals and the global art party: in 2015, the effect of Arles del Rio's creation of a beach on Havana's famous sea-front

esplanade, the Malecon, was undermined because people stole the sand to carry out their own much-needed building work

Coco Fusco writes of the restructuring of Cuban art around foreign patronage at the Havana Biennial of 2000:

> Planeloads of American and European curators arrived...they were shepherded to select studios and exclusive cocktail parties, and escorted to the main exhibition, an event that was far too expensive for most Cubans to attend. There, for a few hours, numerous video projections and a few live events were activated strictly for foreign onlookers. When other visitors arrived in the days that followed they found few if any machines in operation.

In his piece for that Biennial, *Santiago Sierra Invites You for a Drink*, the artist made a barbed comment about the likely relations of power and exploitation between art-tourists and natives by paying prostitutes to hide in boxes that had been set up as benches for the party-goers (much of his other work plays with such power relations; Figure 5).

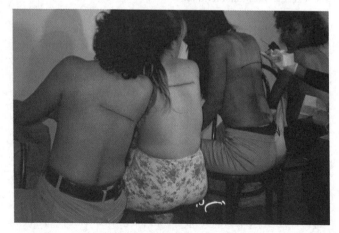

5. Santiago Sierra, *160 cm line tattooed on 4 people*, 2000.

In the early years of their rise, Western models remained powerful in framing the form of biennials and in dominating the art shown there. The point was, after all, the simultaneous integration of far-flung regions into a Western-dominated global order and art world. In a biting essay written in 2005, Elena Filipovic held up to examination the bizarre paradox of the prevalence of white cube display in global biennials. If diversity and hybridity had really been achieved, why was this conservative and ideologically loaded form still the standard, with its dubious urge to seal off both work and viewer from the world in a pure, ideal, and vacant space?

Until recently, the filtering of local material through the art system ultimately produced homogeneity. This system—not just the curation but the interests of all the bodies, private and public, that still make up the alliances around which biennials are formed— tended to produce an art that spoke to international concerns.

One remarkable example was Alfredo Jarr's work, *One Million Finnish Passports*, shown at the international art festival, ARS 95, at the Museum of Contemporary Art in Helsinki. Jarr made slightly altered copies of a million Finnish passports and arranged them in an impressive block, reminiscent of minimalist constructions, behind a security screen. The passports stood for all those that would have been granted to migrants had the Finnish government permitted immigration at the rate of the rest of Europe. On the insistence of the Finnish immigration authorities, Jarr's piece was later destroyed.

This work was typical of globalized art production in many ways. It used literally local material, ordered within the cosmopolitan language of contemporary art to get at the intersection of global and local concerns. It took the side of the migrants, and arguably the interests of global capital, by suggesting that people's right to resettle must override any national determination, even one democratically arrived at, to resist social change. Long pre-dating

both the migration crisis caused by US-sponsored wars in the Middle East and North Africa, and by demographic pressures and climate change, and the right-wing populist response, Jarr also sought to expose a little-discussed, subterranean racism. It also pointed to the deep contradiction that underlies the neoliberal system, which grants mobility to capital but withholds it from labour, except under illegal and often lethal conditions that supplies business with an able-bodied and hyper-exploited workforce.

So at first, it seemed, the biennials put new content into solid old containers, with little fundamental change. But as the system developed and grew, other changes took hold. Some biennials developed successful outreach, education, and discussion programmes, as in Gwangju where a number of fundamental topics have been broached, including democracy, the environment, and Asian cultural identity, and where visitor numbers have far exceeded those of Venice. Sometimes these have been linked to ground-breaking research programmes, as in the events (and later books) that preceded Enwezor's Documenta XI on unrealized democracy, truth and reconciliation, *Créolité*, and African urbanism.

A great deal of variation became apparent: to take one example, the Kochi-Muziris Biennale in southern India, an artist-curated event in another historic port city, successfully fostered South–South artistic dialogues, especially through commissioning work, while building close links with its region. It spoke clearly to a huge local audience, which it carefully cultivated by collaborating with schools, colleges, and other local bodies. Its first two editions attracted a million visitors, mostly local, not far behind Venice. As US and European power waned, other regional and national blocs pursued their own concerns and alliances. An East Asian biennial circuit emerged which highlighted regional concerns, traditions, and aesthetics, and linked first Gwangju,

Fukuoka, and the Asia Pacific Triennial of Contemporary Art, in Queensland, and then came to take in biennials in Shanghai, Taipei, Singapore, and Nanjing, among others. At one such event, in the port city of Guangzhou in 2015, pitched as the First Asian Biennial, artists were invited to reflect on the notion of 'Asia time'. Among the responses was the Big Dipper group's mournful recreation of a garment sweatshop, in which ranks of dusty old sewing machines were accompanied by a slideshow of women at work set to plaintive music. Here Asia time was lives spent in repetitive servitude.

The art changed too, as we shall see in more detail in Chapter 6, and work that was alien to Western concerns and forms became prominent. To take one example: when people act together in an insurgency, they create themselves as an emergent and mutable unity, and suddenly start to see themselves as a collective. The results are seen in photography and video, and in a street art which is dramatically different from the usual run of individualist self-advertising. It is also immediately threatening to the state, which, as in Egypt, takes swift measures to destroy it, and to imprison its artists.

Latifa Echakhch's *Crowd Fade* (Figure 6), shown at the Istanbul Biennial in 2017, was a fresco arranged in a long, narrow corridor, showing crowds of protestors, arms raised in defiance, faces covered, sometimes embracing one another. While these could have been protestors anywhere, the figures were based on photographs of the Gezi Park protests, which had defended a collective green space from commercial development, and had been brutally suppressed by the Turkish state. In evoking the failure of the movement and its violent suppression, the fresco was shattered, and fragments of the 'people' had dropped at the viewers' feet. As we shall see in Chapter 6, works would also come to the fore that documented and celebrated the insurgent collective.

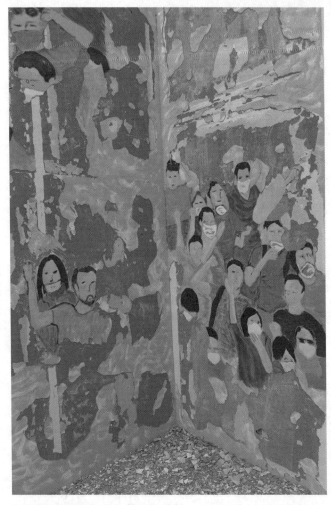

6. Latifa Echakhch, *Crowd Fade*, 2017.

If the biennial at first produced a homogeneity reflective of the one-superpower order of the post-Cold War world, that uniformity was barely sustainable given the extraordinary diversity of experience in that world. Two contrasting cases may illustrate the point, in the very different work produced by the shock of exposure to neoliberal economic forces, in Russia and Scandinavia; and then in work from two nations that have retained communist governments, China and Cuba.

Russia and Scandinavia

In the 1990s, both Russia and Scandinavia were newly exposed to extreme market pressures. In Russia neoliberal economists from the West advised the Yeltsin government that a swift, sharp exposure to the market—'shock therapy'—would prove painful in the short term but would later produce rapid enrichment. A tiny number of Russians became fabulously wealthy as they were sold state assets at risible prices (some were to become major collectors of contemporary art) but the results for the nation as a whole were catastrophic, with the collapse of the most basic services, rampant crime, plunging life expectancy, and widespread destitution.

Out of this disaster, art from Russia and the former Soviet republics came to wide attention, as fragments of social degradation were served up for the delectation of art audiences in the West. Boris Mikhailov made a series of photographs in which he paid homeless people to pose and expose themselves for the camera, highlighting the oppression contained in the offer of the body for money (Figure 7; in this, he is close to the work of Santiago Sierra, who also pays people to undergo various humiliations and exposures). In By the Ground (1991) and At Dusk (1993) he simulated the look of photographs of the early 20th century in depicting the way that the impoverished inhabit Ukrainian streets.

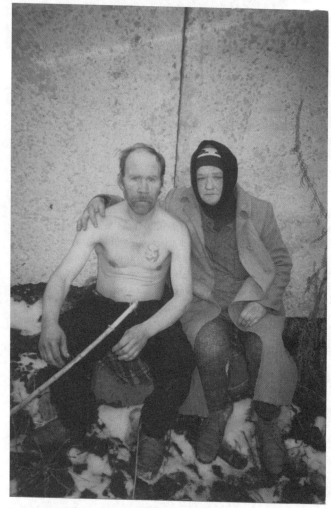

7. Boris Mikhailov, from *Case History*, 1997–8.

Subject-matter as well as style evoke the pre-Revolutionary era. Here is an effective visual analogue to the feeling that many have in post-Soviet society of history and progress being thrown into reverse, as the capitalism that was supposed to transport them into a privileged consumer present instead produced a layering of time-frames, pushing many back to the deadly penury of Czarist times.

Such work is indicative of the premium that post-Soviet reality held in the Western art world. It was found in photography and film, with all the old postmodern lessons about representation dimly remembered, but even so taken as real. Or it was acted out in expressive performance, as in Oleg Kulik's *Dog* in which the naked artist assaults his audience, trying to bite them, in an apparently authentic expression of Russian abjection and degradation.

The appeal of such work for Western audiences is clear enough: an exotic brew of burgeoning capitalism (with its robber barons and swashbucklers or, otherwise put, large-scale swindlers and gangsters), and of the sudden birth of a white European developing world; of the romance of a crumbling 'evil' Empire and a fallen enemy; and of an ideology passed into history. Russianness, encompassing all of this, plays best when overtly displayed.

What it is harder for Western audiences to grasp, perhaps, is how these works do not necessarily plot the exotic otherness of the Slavic soul, or even Soviet history, but refer instead to a capitalist present. Mikhailov's work is about nothing other than the effects of an unrestrained capitalism in which everything is for sale. Kulik's *Dog* is surely an update of Bulgakov's satirical tale, *The Heart of a Dog*, in which a dog is surgically altered to take on human form, and thrives in Soviet society of the 1920s, precisely because of his base instincts. Yet the society that Bulgakov dissected was in tactical retreat from an attempt to foment

revolutionary communism and was using free-market measures to stimulate the economy; in the period of the 'New Economic Policy' a class of nouveaux-riches sprang up, flaunting their often dubiously acquired wealth. It was, in other words, a milder version of Russia today.

Victor Misiano brilliantly summarized the character of 1990s Russian art, encapsulated in the word *tusovka* (shuffling), a scene of intense personal competition and fervid internal discussions, governed by regional brand leaders: while the scramble for success was ruthless (and largely judged by the yardstick of how far others can be sucked into a new project, and how far it can 'invade' the international art world), it was devoid of ideological and ethical issues, and was incapable of self-analysis. As he puts it, symbolic values were privatized with the same 'insatiable eagerness' as state property. In a sense, though, what he describes is no more than an extreme and, because suddenly transformed, sharply visible version of what is common in art scenes elsewhere.

By contrast, in the 1990s Scandinavia's efficient social-democratic economies were forced in a neoliberal direction through the deregulation of financial markets and the abandonment of foreign exchange controls. The process was made worse by the recession of the early 1990s, which forced Scandinavian governments partially to dismantle the social programmes for health and welfare that their citizens had long taken for granted. Unemployment, an unwelcome novelty, rose as manufacturing industry collapsed. Mass immigration began to transform what had been quite enclosed and homogeneous societies.

In Scandinavia, as elsewhere, modernism and social democracy had been strongly associated. Just as social democracy had long survived the right-wing and neoliberal forces that affected much of the rest of the world from the late 1970s onwards, in the Scandinavian art world a clean, constructivist modernism also survived. The recession and its consequences led to a shift in the

role of art from utilitarian design and the creation of utopian-constructivist projects to overt critique. Social-democratic governments had financially supported the arts, making artists insiders, in a way that was hard to deny, as many did elsewhere. This continued into neoliberal times, even as artists struck up antisocial poses. A collection of Scandinavian artists' writings—tartly entitled *We Are All Normal (and We Want Our Freedom)*—contains a passage that puts the matter well: 'The artist seems to act as indicator for the degree of freedom in Scandinavian society, and as much as the artist refuses society—as the traditional role of the artist—the more he affirms it.'

The collision of those well-protected societies with hard economic forces produced a bright and variegated shower of never-before-seen cultural particles. As a result, contemporary Scandinavian art came to global attention, along with its music and cinema. The consequences of the new situation were plainly seen in the exhibition *Organising Freedom: Nordic Art of the '90s* in 2000. As the exhibition's curator, David Elliott, states in the catalogue, these artists 'seem seriously pissed off' about something, and they have issues with (among other things) rational architecture, utopian dreams, idealism, and social engineering. Jakob Kolding uses constructivist forms in his collages, pitching old, radical visions of extreme disorientation (as found in the Russian revolutionary avant-garde) against the politely regulated architecture and social planning that were its Scandinavian progeny. Kolding was brought up in one of Copenhagen's model suburbs in which everything was safely pedestrianized, and shops, schools, nurseries, and clinics were close to hand. This, we are meant to assume, is a terrible fate, and doubtless it must be until these facilities are closed.

The universal modernist 'Man' of basic needs splintered into the shards of competing interests and antagonistic identities. Miriam Bäckström has photographed show interiors at the Ikea Corporate Museum, a series of cramped and sterile spaces. Ikea's mission is a

modernist, egalitarian, and social-democratic one: the rational, frugal, and gradual improvement of domestic space. Bäckström, like many other contemporary Scandinavian artists, views the effect of modernism as claustrophobic. It is easy to imagine the ideal absent inhabitants of her interiors: contented, measured, rational characters at home with homogeneity. Artists, by contrast, expose the underbelly of that rational culture with relish, highlight the problems surrounding the arrival of immigrants from other cultures, and celebrate the diverse claims of identity politics. Bjarne Melgaard, an artist whose work deals with gay sexuality, took a trip to Tahiti and once there masturbated over Gauguin's grave. The spectre of modernism haunts Scandinavia (so little time having passed since the funeral) and requires continual exorcism. Throughout the 1990s, many artists were still busy hammering down the lid.

Nevertheless, judging by the conditions of democratic life elsewhere, the route down which these social democracies were moving was clear enough. Måns Wrange's project *The Average Citizen* examined the new conditions in which power has shifted from a politically constituted public to those who professionally manipulate public opinion and the political process. It takes the concept of the average citizen as modelled by the Swedish welfare state and, having identified one such statistically average person and questioned her about her political opinions, used professional tools including lobbyists to advance her interests. Her views reached the public in political speeches and through the mass media. Polls were used to test the efficacy of these strategies, and one of the most effective interventions was made by putting her opinions into the mouth of a character on a popular TV series. This acidly amusing work examines the corruption of the public sphere by PR, mocking both the old attachment to the human mean, and the fraudulence of the new system. It further suggests that the fragmentation of the social body under the pressures of economic recession and cultural divergence has played a part in

opening politics to the manipulation of competing groups, the most powerful of which are moneyed.

David McNeill, in a fine article about art and globalization, tells of a notorious incident at the exhibition *Interpol* held in Stockholm in 1996, which brought together young Swedish and Russian artists who were supposed to collaborate. As the show developed, artists of other nations were added, and Gu Wenda, without reference to any other exhibitor, made a tunnel laboriously woven of human hair. At the opening, Alexander Brener, a Russian performance artist, hacked the tunnel to pieces with a machete. Police were called who arrested Kulik, in dog-mode trying to bite a child, as Brener escaped. While Gu Wenda saw the destruction of his work as Dada-inspired frustration typical of a degenerate and chaotic Russia, Brener was provoked not only by what he saw as the shabby treatment of the Eastern European contingent by Western curators but also by the diluting of the original concept into a typical global love-in. Here is his own statement about his action:

> The next day there was a news conference at which I was called a fascist. No, my dear chaps, I don't agree. At this exhibition I was the only democrat who had openly declared his position and demonstrated his disagreement with the organizers. Radical democracy in action! Bang on simulation and neoliberal vulgarity!

The following year, Brener became widely notorious for another piece of principled iconoclasm, in which he spray-painted a dollar sign on Malevich's *White Square on a White Background*, in the Stedelijk Museum. Brener saw it as a protest at the reduction of Malevich's attempts to profoundly transform art and the world alike to mere money value. This time he was jailed.

Cuba and China

Art from communist nations in the era of the new world order had a different appeal than that from post-communist states such as

Russia. From being seen through a Cold War lens as improbable antediluvian survivals in a thoroughly marketized world, Cuba and China have moved to a position in which both embody aspects of future responses to intractable global problems. China pursues a state-guided capitalism, which keeps its super-rich under discipline (with, among other measures, the occasional execution to remind them where power really lies), and melds the market with concerted strategic planning. Cuba, in an extraordinary post-crisis greening of its cities with huge numbers of vegetable patches, approaches an organic self-sustaining food system.

Diverse work that broke with the precepts of socialist realism began to be produced in China following the end of the Cultural Revolution, some bearing on religious themes, some furthering a Marxist humanism, and some (from the late 1980s onwards) engaging with the new and fast-growing consumer culture. Global interest was directed at Chinese art in the short term because of the massacre of dissidents in Tiananmen Square in June 1989, which led to a focus on artists who could be read as oppositional. Long-term worldwide attention was sustained by the emergence of regulated markets in China and the rapid generation of great wealth and inequality, along with extraordinary economic growth; there was also (in marked contrast to Russia) a dramatic improvement in living standards for most people, and the creation of a vast pool of consumers.

The artistic trends that followed these dramatic changes are plotted by Gao Minglu, who notes that by 1988, as capitalist development in China accelerated, those artists who had been concerned with grand spiritual and humanistic themes tended to forget them in favour of more explicit social comment. One prominent artist, Wang Guangyi, called for the liquidation of humanism, asserting that art is created only to achieve success in the media world and the market. A major element of this new work was a resurgence in representations of Mao, suitably reconfigured to fit the new political and cultural climate. This was

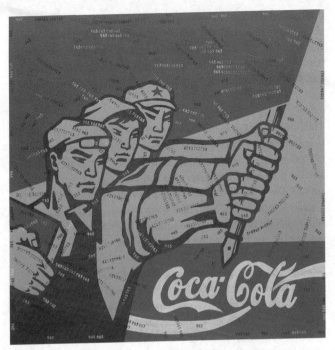

8. Wang Guangyi, *Great Criticism—Coca-Cola*, 1990–3.

Mao and Socialist Realism seen through the lens of Pop Art, in an image simultaneously kitsch and nightmarish (Figure 8).

The situation of Cuba is very different, of course, it being a small island nation neighbouring a hostile superpower which has subjected it to decades of blockade, covert terrorism, and subversion, and often threatens worse. Relations with the exiled Cuban population are fractious and even dangerous: in 1996, Gerardo Mosquera, a well-known and important curator, historian, and critic of Latin American art, had an invitation to speak at the Miami Center for the Fine Arts withdrawn, because the fact that he maintains a residence in Cuba made him

unacceptable to the likely audience. The Cuban Museum of Art and Culture in Miami was twice bombed because it shows resident Cuban artists. In another way, however, Cuba is well suited to the new globalized situation because of its ethnic and cultural mix, and relatively harmonious synthesis of African, European, and American elements.

The initial reaction of the regime to the fall of Eastern European communism, and the sudden cessation of Soviet subsidies, was a crackdown on artistic freedom: avant-garde shows were closed, and the government minister who had sanctioned them was sacked. The artist Angel Delgado—who had publicly defecated on a copy of the official Communist Party newspaper, *Granma*—was sent to jail. In response, most avant-garde artists who had emerged in the 1980s emigrated in the early 1990s.

Since then, as Mosquera recounts, international scrutiny over human rights coupled with the revival of a market economy and the search for foreign investment have acted in favour of cultural openness. The 1990s generation of successful Cuban artists remained in Cuba, since they were allowed to travel and, importantly, to sell works for dollars, enabling some of them to live very well. A muted and negotiated criticism is permitted, and work is sometimes discussed with the censors. Mosquera writes: 'the danger exists that this critical element may become stereotyped as an attractive trait for exportation. Political criticism has become a selling point for foreign galleries and collectors.' As we shall see, getting yourself arrested by a communist regime is one route to artistic stardom.

Since 1989, the regime has oscillated between episodes of liberalization and repression. As the mass media remain under censorship, and artists are allowed limited freedom to criticize the regime, this is a quasi-legal formalization of the *de facto* structures in the West that ensure that the mass media foster political orthodoxy (this has long been the subject of analysis by Noam

Chomsky), and politically radical art is most likely to get an airing at biennials.

In both China and Cuba, capitalist-communist hybrid propaganda art was widely produced in the 1990s: one can compare the work of Wang Guangyi and José Angel Toirac, who produce images of Mao and Castro, respectively, spliced with commercial advertising material.

Toirac had Castro appear in a Calvin Klein Obsession ad (Figure 9), the obsession here being the US determination to remove him. When a *cigarette*-smoking Castro crops up riding a horse in Toirac's Marlboro ad, it becomes evident what compact is signalled by the title of the series, *Tiempos Nuevos*, or *New Times*. He has also reworked famous documentary photographs of the Revolution using his friends, playing up the rhetorical quality of the originals.

Such parallels should not be surprising, for both the Chinese and the Cuban governments had relaxed their hold on their economies, permitting limited private enterprise, and necessarily allowing commercial publicity to creep in. So both populations are assailed with state and corporate propaganda, each striving to convince them of the singularity of their products. In the West these works played sweetly both as registers of the decline of once fearsome enemies and ideologies to the level of mere image, and as examples of cultural hybridization. This relaxed attitude towards actually existing communism allowed the incorporation of its symbols into contemporary culture with no more frisson of danger than the appearance of Che Guevara's head on a T-shirt.

In both nations, at least until recently, the most successful work on the global scene acted out overt Chineseness or *Cubanismó* for a Western audience. In much prominent Cuban art, for example in the work of Kcho and Los Carpinteros, there was a strong element of low-tech production, of creative invention with gleaned

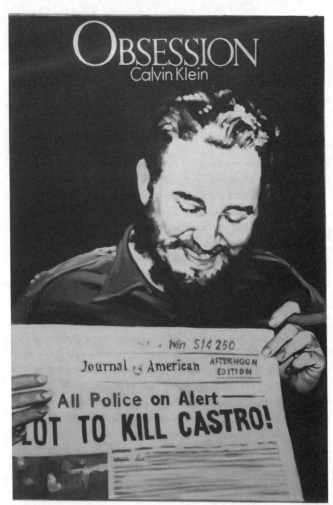

9. José Angel Toirac, *Obsession*, from the series 'Tiempos Nuevos', 1996.

materials, and the use of old craft skills. This was partly no doubt out of necessity, but is also a meeting of Western expectations about Cuba. Two of China's most effective exports, Gu Wenda and Xu Bing, take as their main medium of expression Chinese calligraphy. More generally, the criteria for inclusion were quite obvious—work should reflect Chinese conditions that are well known and of concern in the West: political repression, economic growth and consumerism, the subjection of women, and the control of family size. These overtly 'Chinese' concerns should be expressed in recognizably contemporary Western modes to produce a manifestly hybrid object.

This was made very apparent to me on seeing a selection from the *Ninth Chinese National Art Exhibition* shown in Hong Kong in 2002. The painting section of this show was a large, impressive and technically accomplished display of socialist-realist depictions of contemporary Chinese life, rendered in a wide variety of styles. Some work, such as Wang Hongjian's melancholy painting of migrant labourers waiting for transport home in the moonlight, spoke directly and eloquently of people's experiences in a rapidly changing society. Other pieces, such as Zheng Yi's portrait of broadly smiling rural folk in the sunshine, seemed (to my eyes) hopelessly kitsch—*Plain Souls Burn Bright* is not a title you would get away with irony-free in London or New York. Lacking the required Western references (there were many, in fact, but to older styles, including impressionism) and the appearance of uselessness, since they all had an overt propaganda function, such works were genuinely different from Western productions and therefore invisible to the global art system.

By contrast, we can look at two global successes, Xu Bing from China and Kcho from Cuba, whose work is representative of what is looked for in such art. Xu Bing, a staple of the biennials, became celebrated for a work he showed in Beijing in 1988, *Book from the Sky* (Figure 10). This was an extraordinarily labour-intensive fabrication of 1,250 invented characters, derived from the

10. Xu Bing, *Book from the Sky*, 1987–91.

elements of Chinese ideograms but meaning nothing. These
characters were used to create large, impressive installations
of scrolls and books, presenting Chinese readers with the
appearance of great expanses of meaningful text, all of it
obdurately unreadable. It was a long-running project,
changed as it was installed in different venues, adopting
computer technology and spawning collectors' books.
The work proved controversial in China, where it was both
attacked and defended, and it became associated with the
avant-garde production put under pressure by the
authorities following the Tiananmen massacre. Xu Bing
himself, quoted by Stanley K. Abe, said of the work's noisy
public reception, following the long period of solitude during
which he had made it:

> Handing one's work to society is just like driving living animals into
> a slaughterhouse. The work no longer belongs to me: it has become
> the property of all the people who have touched it. It is now
> concrete and filthy.

In a remarkable article, Abe charted the various readings of *Book
from the Sky*. Once exported from China, the work changed
profoundly, for most of the new audience could not attempt to read
the characters or sense their strange familiarity. When it was seen
in the US, it was only through the lens of Tiananmen, as an allegory
of good (individual expression) versus evil (oriental despotism). Xu
Bing did not sanction these readings but neither did he reject them.
In any case, as the reading broadened out from the concern with
Tiananmen, it was only ever read as a critique of Chinese traditions,
institutions, and history, and never, for example, as a general
comment on language, interpretation, and meaning.

Gao Minglu has put the matter of misreading forcefully, writing of
how critical avant-garde activity gave way to a pragmatic art that
courted favour on the international stage, but was still read by
many in the West in Cold War terms. He goes on to argue that
much of this so-called 'avant garde' is complicit with the
promotion of consumer culture in China (its attraction to Pop Art,
then, being no accident), and that what may seem vanguardist
when seen from outside China can look reactionary from inside.
Pitched against this globally marketable art is what Gao calls
'apartment art', shown in private spaces or in the street, and
comprised of ephemeral and unsaleable works. An example was
Wang Jin's extraordinary ice wall made outside a major new mall
in Zhengzhou City in 1996. Embedded in the ice were many
luxury consumer items which the public took to digging out
however they could, finally destroying the wall.

We may also think of that strain of work that collaborates with
people outside the art world: for example, in *China Village*

Documentary Project, Wu Wenguang had ten farmers make videos of the lives of their communities. Most of his subjects were very unused to being filmed or photographed, had never picked up a video camera, and were not surrounded by photography. Their visual environment was remarkably free of representations, aside from a few political posters. Many of the documentary makers focused on village self-governance which is meant to reintroduce political processes into areas which would otherwise be left solely to market forces. These structures and the power that they endow have been the subject of a great deal of debate, and vary greatly from village to village, but what comes across strongly from the videos is the noisy, chaotic, discursive, sometimes good-humoured, sometimes fractious, and bitter character of these local decision-making processes, in which people become used to exercising some limited power over their lives and environments. Or again, the remarkable Long March project, directed by Lu Jie, reversing the direction of Mao's famous 6,000-mile trek, so as to produce a cultural exchange from which both sides (artists—including Xu Bing and Judy Chicago—and the people en route) would learn, and co-produce work in a meeting of the global and the local. It has fostered some very long-term artistic projects (such as Yang Shaobin's painting and documentary work on the lives of coalminers in his hometown of Tangshan) and has in some places collaborated to build rural infrastructure.

Kcho makes sculptural pieces, mostly from wood, typically comprising stacks of elements that are reminiscent of the frames of small boats. He achieved very rapid success after showing at the Havana Biennial in 1994 and the Gwangju Biennale the following year. Taken on by the prominent New York gallery, Barbara Gladstone, his large sculpture, *Infinite Column I*, was purchased by the Museum of Modern Art in the year it was made, 1996. This piece was one of Kcho's makeshift boat skeletons, sculpturally spliced with references to European modernism (in this case, Brancusi's *Endless Column* of 1938), which clearly refer to the tragic attempts at exodus made by Cubans following a US

declaration that all who made it to their shores would be accepted as citizens. As with Xu Bing, a manifestly national subject, rendered with an artisan's skill, is framed within an acceptable contemporary art format.

Much of this art, while it draws on the resonance of political issues, takes no explicit stand, and is characterized by ironic or mute politics. Coco Fusco, in an article for the art magazine *Frieze* (and reprinted in her book, *The Bodies That Were Not Ours*), tried to put the politics back into Kcho's work, particularly by looking at its use by the authorities in the Havana Biennial. For such cheek in analysing a new darling of the market she received threats, and the magazine had to deal with complaints from Kcho's dealers. It says much about the level of art writing in such magazines—and the degree to which powerful dealers and art institutions ensure servile 'criticism'—that her essay should stand out so dramatically from the critical landscape.

At least until the financial crisis took hold, in much prominent global art, identities were paraded for the entertainment of cosmopolitan viewers. Features of cultural mixing, irony, and the overt performance of identity are comforting to the Western eye, which (as Slavoj Žižek controversially argues) is only secure with otherness as long as it is not really other. The results have been well summarized by Fusco: that globalization has transformed the art world, along with the management of racial and cultural difference, to follow the model of corporate internationalism. Visibility in the realm of culture is no guarantee of political power, and the increasing privatization of museums and galleries erodes the influence that once might have flowed from that visibility. Instead, diversity is normalized while its critical content is sidestepped.

The point can be made most literally by looking at the migrations of the artists themselves: their origins may be diverse, but so many—and by no means just those who have fled states with legal

censorship—end up living in New York, the great art vortex. In her quantitative study, Chin-tao Wu has shown that while the diversity of artists shown at the grandest of contemporary art events, Documenta, held in the German town of Kassel, as measured by place of birth did increase, and markedly so with Okwui Enwezor's Documenta XI in 2002, a great many artists born outside of North America and Western Europe emigrated there, and did so before they were shown at Documenta.

Yet much of this art, despite its dubious attractions in the West, does say fascinating things, and works at a level of intensity and engagement rarely found in comfortable and settled societies. Writing of theory, Fredric Jameson has convincingly argued that the most systematic works are produced in circumstances where, due to combined and uneven development, thinkers are faced with extreme contrasts of scene, in which they can apparently step from one historical era to another. Peasants in paddy fields may raise their eyes from their labour to glimpse a new neighbour, a high-rise postmodern office complex. Such contexts, says Jameson, foster systematic and totalizing thinking about historical change. With art, there is no expectation of such systematic qualities, but those circumstances do have an effect, particularly in thinking beyond the ubiquity of consumer culture. Equally, so long as the economy functions as planned, one would expect the flattest, most fragmentary, and most defeatist art to be produced in the oldest and wealthiest neoliberal economies, particularly the US and UK—and indeed, as we shall see in Chapter 3, it is.

Furthermore, as it became clearer that the world would not be forever dominated by a single superpower, and as powerful counter-poles emerged, art was made that spoke inwards as well as outwards, and had no necessary need of Western approbation. In Russia, the effects have been very marked. As the assorted chancers and political *apparatchiks* who had become vastly wealthy through the 'sale' (if one can call it that) of state assets in oil, gas, and minerals, settled into the lifestyle of the global

mega-rich, they took up collecting contemporary art. From 2000 onwards, they started to spend vast sums, fuelled by the Russian oil boom. Their values usually align with those of the state that enriched and defends them: a mix of authoritarianism, orthodox religion, and hard-line nationalism that insists upon a distinctly Russian identity in contrast to the West. As Tony Wood points out, one of the dividing lines is the parade of Russian heterosexual normality against a decadent and deviant Occident. In a telling enactment of the alliance, the Patriarch of the Russian Orthodox Church had declared Putin's rule a 'miracle of God'.

As a satellite show of the 2007 Moscow Biennial, Kulik curated 'I Believe' in a brewery turned art space, where he exhibited many quasi-religious works in a vaulted underground space laden with incense. At its centre, in a yurt, sat Kulik himself, dispensing spiritual nostrums to a crowd who apparently took the performance seriously. It was evident that this exhibition was not made primarily for the consumption of the Western art tourist. In another telling incident, the 40,000 euro Kandinsky Prize, supported by Deutsche Bank and the Guggenheim Foundation, was awarded in 2008 to Alexey Belyayev-Gintovt for a series of canvases named 'Motherland-Daughter'. The artist is a cheerleader for a renewed Russian imperialism, and the paintings showed women in traditional dress holding a Kalashnikov, an axe, or a scythe, with such inscriptions as 'Glory to Russian Arms', 'Absolute Motherland', and ominously 'Return Everything'.

Under this new political, religious, and cultural compact, as under the Soviet regime, even the most marginal dissent threatens to break the fragile spell, and must be punished harshly. So when in 2012 Pussy Riot staged a brief protest in Moscow's Cathedral of Christ the Saviour, singing their 'Punk Prayer' objecting to the Orthodox Church's support for Putin, and in particular the Church's condemnations of homosexuality, they faced trial for 'hooliganism motivated by religious hatred' and were eventually jailed. Maria Alyokhina's eloquent account of her dissent and

punishment gives a flavour of the threatening conformity of everyday life, along with its many absurdities. Pussy Riot are only one instance of Russian artists being prosecuted for their work, or being forced into exile.

Both the oil-fuelled boom and this resurgence of reactionary cultural pride were fragile. The market for Russian contemporary art fell into stagnation from 2007 as their mega-rich, following the conventional diktats, detached themselves from their home nation and bought internationally. A further fall was brought about by the conflict in the Crimea, the subsequent sanctions, and the declining value of the rouble from 2014. Artists, faced with (as Ilya Budraitskis put it on the hundredth anniversary of the October Revolution) a society of the eternal present 'wallowing in apathy and mired in a state of continuous, mounting crisis', began to turn towards political engagement and even Marxist ideas, and drew particularly on dissident art of the Soviet era.

In China, briefly, from the mid-2000s onwards, experimental work began to be taught in the academies, and underground artists were brought into major exhibition spaces. One of the most remarkable instances is the transformation of Zhang Huan from radical dissident performance artist, lauded in the West, to painter, sculptor, and video artist inhabiting a vast studio in Shanghai, employing eighty assistants. Among his recent works, a huge animatronic bust of Confucius immersed in a mirroring pool.

A shift was marked by the 2008 Beijing Olympics, in an extravagant display of Chinese political and cultural power, opening with a massive firework display by artist Cai Guo-Qiang. It also coincided with the financial crash, which was to shift the economic balance in favour of China, and with the rise of wealthy domestic collectors and patrons, some of whom founded their own museums. The Western viewer is no longer so much courted, and an art that mixes high-tech spectacle and polished craft practices, and nationalistic references to venerable cultural

traditions is prominently shown. For instance, the Chinese pavilion at Venice in 2017 had an exhibition called *Continuum: Generation by Generation*, curated by Qiu Zhijie, meant to demonstrate the interchange between ancient and modern, tradition and innovation, and permanence and transformation, which it did in part through a mix of large projections and elaborate carvings casting shadows by Wang Tianwen, Wu Jian'an, and Tang Nanan. As in Russia, but with a good deal more efficiency, artistic dissidence was suppressed, overpowering forms of state control came to the fore, and lavish rewards were offered to the compliant.

So, as other powers emerged to challenge the US, and as neoliberalism fell into disrepair, new worlds were revealed: in some regions—above all, China—it no longer became mandatory to appeal to the West, and an art emerged that was genuinely independent, and spoke mostly to Chinese concerns. The contents had corroded the container. And, as we shall see in Chapter 6, across the globe, radical anti-neoliberal and even anti-capitalist works emerged.

Chapter 3
Consuming culture

If the economic expression of neoliberalism is growing inequality, and its political expression deregulation and privatization, then its cultural expression is unrestrained consumerism. While the 'new world order' caused the art world to refashion itself by globalizing its operations, it also came under intensifying pressure from its old rival and partner, mass culture. Since at least the early years of the 20th century, with the invention of cinema, the phonograph, and radio, the two have been entwined in an unequal dance, mass culture generally leading.

Contemporary artists tend to handle the issue of consumer culture with fascination and nervousness, and there is good reason for both reactions. Fascination, because consumerism appears to become ever more cultural, as much concerned with selling or merely displaying images, sounds, and words as it is with material things, and increasingly fixed upon events as much as objects. Nervousness, because the engines of this production are so vast and lavishly funded, their output so strident and omnipresent. If commodities are cultural, what space is left for art?

It is an old worry, found in modernism as well as in postmodernism, though in different forms. Fernand Léger stood before the machine exhibits of the Paris Fair in 1924, marvelling at how such immaculate productions outshone the poor, self-conscious

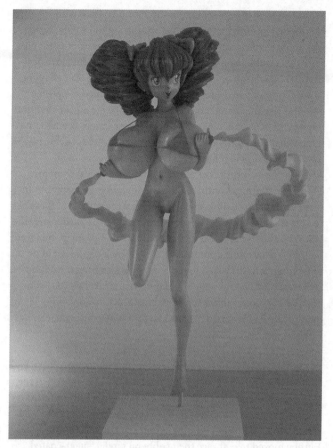

11. Takashi Murakami, *Hiropon*, 1997.

efforts of artists. The argument that art is no longer possible
because the world of products is saturated with aesthetics is the
postmodern variant of the same anxiety. There, the key modernist
dream of the merging of art and life has been realized, though less
in synthesis than the surrender of the weaker party.

While the issue of art's separation from or mergence with commodity culture has a long history, during the 1990s there was an intensification of the forces involved, many of them old features of capitalism, which contributed to the dominance of a triumphant consumer culture not just over art but over all other cultural production. Many consumer goods seemed to become even less like functional objects and more like evanescent cultural moves within a sophisticated, self-referential game. Brand names hopped between unrelated products, while advertising churned over reference, self-reference, and meta-reference in an accelerating absorption of old and new cultural attachments. The greatest profits continued to be made not in industry but in services, data processing, and finance, and the success of those sectors was strongest in the neoliberal economies, particularly the US. With the rise of social media, feedback and participation were built into data-mining enterprises so that each digital act of self-expression was yoked to the gargantuan engines of commerce. As a result, while art is still not play-tested, it is now exposed to popular taste and subject to algorithms which spy on and manipulate its viewers. This has had profound consequences, as we shall see.

In the West this change to neoliberal regime and rampant consumer culture had been felt as early as the mid-1970s but the 1990s saw the collapse of alternative models, not only in Eastern Europe but also in the great industrial economies, Germany and Japan, which both suffered stagnation and decline. Continental Europe moved to embrace the neoliberal model, sugar-coated though it was through much of the mid- and late 1990s with nominally social-democratic governance. At least until the financial crash of 2008 the neoliberal model, like commodification itself, widened its ambit and deepened its hold.

We have seen that in some of these territories (including Scandinavia), which recession had newly opened to unrestrained and corrosive market forces, art served as an agent of

neoliberalism, trampling over the comforting if suffocating amenities of social democracy, and giving expression to the liberated concerns of identity politics, consumerism, vulgarity, and pleasure in the degraded. Such works served as useful, if minor, allies of privatization and the colonizing force of commodification as it trampled over the commons. The parallels between the orthodoxies of postmodernism and the free market ethos have often been drawn out. Michael Hardt and Antonio Negri, in their influential book *Empire*, put the matter well:

> The ideology of the world market has always been the anti-foundational and anti-essentialist discourse par excellence. Circulation, mobility, diversity and mixture are its very conditions of possibility. Trade brings differences together and the more the merrier! Differences (of commodities, populations, cultures, and so forth) seem to multiply infinitely in the world market, which attacks nothing more violently than fixed boundaries; it overwhelms any binary division with its infinite multiplicities.

This is no coincidental similarity, but rather (as Fredric Jameson pointed out in his foundational essay on postmodernism) a functional relation: aesthetic components are integrated into the production of consumer goods, which are altered at the ever-accelerating tempo of fashion. The companies that produce such items also financially support their research-and-recycling arm, the arts. Back in 1986, Martha Rosler described the situation in writing about the trend in high-production video art: 'Nothing could better suit the consciousness industry than to have artists playing about its edges embroidering its forms and quite literally developing new strategies for ads and graphics.'

Art may be imagined as consumerism's dreaming, playfully recombining the elements of mass culture in promiscuous assemblages, and along the way happening upon items of use. Indeed, Boris Groys, in a typical provocation, claims that it is the only repository of cultural memory, a prop against an otherwise

amnesiac consumerism. In recombining and storing in museums and archives what has gone out of use, art may also serve a similar purpose to so-called 'junk' DNA, which may hold obsolete sequences in reserve which could be used again.

Corporate culture has thoroughly assimilated the discourse of a tamed postmodernism. It is not often that a 600-page sociological analysis of business management practices becomes a key art-world reference, but this is the fate of Luc Boltanski and Eve Chiapello's remarkable book, *The New Spirit of Capitalism*. Under this new regime, a response to the revolts of 1968, art and business converged in their values and ethos to recommend, in theory if not in practice, creativity, non-conformism, and autonomy. As in mass culture, art's very lack of convention became entirely conventional. Ubiquitous and insistent voices urge consumers and workers alike to express themselves, be creative, be different, break the rules, stand out from the crowd, and even rebel, but these are no longer the words of radical agitators but of business. The writers of the US cultural magazine *The Baffler* vividly describe the extent and standardization of these injunctions. Their wonderfully condensed example of this imperative is William Burroughs' appearance in an advert for Nike.

Postmodern theory itself, as it moved from being an account of a potential utopia or dystopia in which radical, fluid identities challenged mainstream conformity to being a flat description of an existing reality, lost its critical and ethical force. As Pamela Lee argues, it became pervasive, unfashionable, and fatalist. In its reduced state, consumerism and the supposed empowerment of the shopper were central to postmodernism's disquisitions. While in the 1990s postmodern theory was buffeted by attacks on its internal absurdities and its browbeating of readers with meaningless scientific jargon (highlighted in the Sokal Affair), in much of the academic art world, at least, it was less replaced than lost sight of by its acceptance as the unargued background out of which statements about art were made.

Another striking development tended to make the commodity appear less material: branding achieved greater importance throughout the 1990s as corporations spent the money that they had saved on outsourcing production on polishing their own images. Naomi Klein argues in her justly renowned book *No Logo* that, as production was exported to low-wage economies, so the link between the consumers of a product and its makers was sundered. The brand was elevated in compensation, floating free of mere products, to become an allegorical character, an apparently reliable embodiment of particular combinations of virtues or admirable vices. Sometimes, as with Ronald McDonald, it solidified into an animated figure.

On going to the links page of veteran conceptual artist Claude Closky's website, the viewer is presented with an alphabetical list of dotcom sites composed of familiar names, a roll call of contemporary art stars: it begins adams, akerman, alys, amer, andre, araki. All the links are in fact to company sites, so clicking on *www.billingham.com*, for example, takes you to a site selling camera bags. The range of products and services brought together that share artists' names forms a curious little database, and the work encourages the user to think about artists' names as brands, and about the dotcom character of their work.

Artists, as Isabelle Graw has argued, are the ur-celebrities, and lie at the origins of self-branding. Many aspects of the celebrity autobiography are already present in Benvenuto Cellini's preening, entertaining, and unreliable tale, written in the late 16th century. Work under 'creative' capitalism converges with what has long been demanded of artists, many of them inveterate self-publicists, networkers, and celebrities. For Graw, celebrities now exhibit in a concentrated manner what had been required of artists and is now demanded of everyone—to bring their entire life to market, lived as a performance. This can be seen clearly in figures such as Marina Abramovic, Ai Weiwei, and Anne Imhof, for whom life, work, gossip, and PR, online and off, merge to

identity. Ai Weiwei, for example, long known for his activism, especially over the poor building standards that caused so many schools to collapse during the Sichuan earthquake, used dioramas to dramatize the conditions of his eighty-day house arrest by the Chinese authorities, as he was held on the pretext of irregularities in his taxes. This persecution sealed his status as a global brand, just as it would do for Tania Bruguera, when she was arrested by the Cuban authorities for organizing an open-mic event in La Havana's Plaza de la Revolución, which was intended to allow citizens to openly express political opinions. In such works, as with other performance artists, art work and celebrity condense in the body of the artist or its depiction, as in Ai's move to recreate the infamous image of the washed-up body of a refugee child, Alan Kurdi, by having himself photographed lying face-down on a beach.

Branding is not confined to artists. While museums have long had names, identities, and even logos, their explicit branding by specialist companies devoted to such tasks is relatively new. They ensure that all aspects of museum design, from font to front-of-house uniform, reinforce the unitary message. The brand is an attempt to stamp all of an organization's products with the same swiftly recognizable identity which acts as an assurance of reliable quality. Within such an environment, a solo show may be seen merely as a cross-branding opportunity. Artists once renowned for consumer critique played out their styles in other cross-branding exercises—as Barbara Kruger did by repurposing her slogans to decorate the Selfridges' sale. When artist-brand and museum-brand are brought together for a marketing event, as in Tate's 2012 Damien Hirst exhibition, which attracted record-breaking numbers of visitors, the exercise becomes entirely transparent.

Branding is a fundamentally affirmative device which must be simple, unitary, and positive. It may dimly be remembered that at least some modern and avant-garde art is (or was) negatory, anti-aesthetic, contentious, contradictory, made in critique of other works of art, radical, anti-instrumental, and uncomfortable.

Its display in the branded museum environment downplays these qualities, and misrepresents them historically.

After all, the work of art has been an unusual type of commodity. As Dave Beech points out, unlike a chair or a carpet, it rarely fills a pre-existing need; the circumstances of its creation, marketing, and display are often archaic; it is a unique product to which the standard rules of supply and demand sometimes fail to apply; and it is very often enjoyed without being purchased.

Yet, in a double movement as commodities have become more cultural, art's commodification has become modernized, as its market expanded and as it became increasingly integrated into the general run of capitalist activity. A number of artistic practices in the 1990s responded to these changes, feeding off them and pushing them further. Sylvie Fleury took the results of her shopping trips to high-class boutiques and laid them on the gallery floor; or she placed desirable, fashionable items (literally) on pedestals. Fleury also examined different levels of consumer activity, bringing the least glamorous and most utilitarian into contact with conspicuous consumption by gilding supermarket shopping trolleys (Figure 12).

Guillaume Bijl simply opened shops within the museum. For the *Shopping* exhibition at Tate Liverpool, a gallery was turned over to Bijl's branch of the supermarket Tesco. This was maintained by Tesco staff who went about rearranging and repricing goods and tidying shelves. Yet, since no one could actually buy anything, and all the shelves were fully stocked and lit by museum spotlights, the 'shop' became an aesthetic display of multicoloured blocks of packages. In one sense, this was reminiscent of Fleury's shopping trolleys in making the most mundane of shopping experiences into an isolated visual spectacle. In a step beyond Warhol's paintings of soup cans, it discomfited viewers, who were little used to the implied expectation that they should look at the commercial display of tinned goods as connoisseurs.

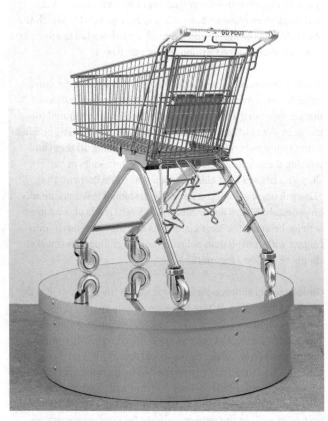

12. Sylvie Fleury, *Ela 75K (Go Pout)*, 2000.

Reading some postmodern pronouncements, one might be forgiven for thinking that no area of culture is immune to art's invasion. For Boris Groys, for example, the art world's radical rejection of aesthetic judgement has produced an abolition of all hierarchy, and an equality of all visual forms, objects, and media. This is hardly the case, and the art world selects its alliances and references with discrimination. There is no sustained interest in darts or pigeon-fancying. By contrast, there has been much effort to bring art and high fashion closer together. A bland statement by Hugo Boss (the sponsor of a Fleury show) reveals through and because of its jumbling of terms the ideological mechanism at work:

> Art and fashion have always gone hand in hand. Sometimes radical
> and shocking, sometimes traditional and conservative, both are
> judged according to subjective standards of taste. Each represents
> in its own way the moods and spirit of the times. They stimulate the
> senses and create objects of desire as fetishes of an affluent society
> and legacies of culture.

Through the 1990s, art and the fashion industry came into increasingly close contact. Art magazines carried more adverts for Prada, fashion magazines contained more features about contemporary art, and genuine hybrids appeared (such as *Tank*, *System*, or *Very*) in which the two worlds acted in symbiosis. Numerous fashion photographers such as Jürgen Teller and Corinne Day produced art books, and their work appeared in galleries as well as on the page. In 2002, Diedrich Diederichsen related the vogue for spectacular art works both to a marked improvement in magazine print quality leading to a greater use of illustrations (displacing text), and the growth of crossover art, style, and fashion magazines. Such publications naturally tend to promote art that can be grasped rapidly by flicking through a photo or two.

The association has since become much more intimate. As Chin-tao Wu notes, very well-known artists (and once-radical

ones such as Daniel Buren and Yoko Ono) have taken to making works 'inspired' by Chanel handbags. Loss-leading flagship shops are designed by globally famous architects at huge expense: sometimes, as in the Tokyo Hermès store, designed by Renzo Piano, they contain galleries, and the artists showing there also make limited-edition handbags or scarves (by artists including Takashi Murakami (Figure 11), Yayoi Kusama, and Hiroshi Sugimoto), melding art and fashion in high-end luxury goods. Fashion magnate François Pinault is one of the wealthiest and most extravagant contemporary art collectors, and his private holdings form a powerful duo in Venice: contemporary art can be seen on a grand scale across the floors of the Palazzo Grassi, one of the most impressive art spaces in the city, while elements of Pinault's private collection are shown at his own large museum, the Punta della Dogana, the city's old customs' house, converted by Tadao Ando at a cost of 20 million euros.

These developments were linked both to the pressures placed on public galleries and museums to commercialize themselves, and to the predilections of exhibition sponsors, but they also reflected a much wider trend in commodity culture to favour youth, or at least its appearance. Youthfulness is an appealing marketing quality even for those art events that attract older audiences who like to think of themselves as sprightly. Youth became an advantage that artists could trade upon in various ways. Artists can remain young for quite a while, or even be labelled 'young', as in Saatchi's branding of the 'young British artists'. They can depict the young, and there is a rash of such portrayals, particularly in photography, where the poignancy of ageing and death is always implied. So Rineke Dijkstra's adolescents pose painfully before the camera on beaches or in clubs; or Sarah Jones's privileged but anomic girls array themselves across decorous rooms, melancholic with some secret knowledge; Wolfgang Tillmans' similarly disaffected subjects appear to reflect on youth's transience; or, in a different register, Vanessa Beecroft's performances, videos, and photographs use models who stand about in various states of

undress, confronting the viewer with the guilt of their own desires and aspirations (Figure 13).

While there are marked business opportunities in this close association of art and fashion, or more broadly, art and commodity culture, there is also a threat. If a total fusion with

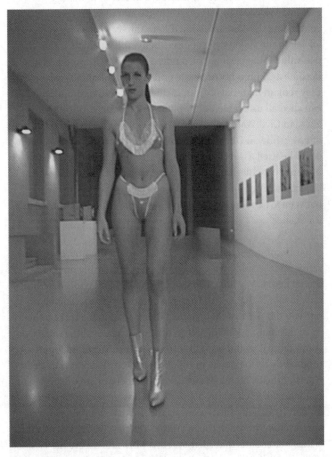

13. Vanessa Beecroft, *VB29.243*, 1997.

fashion or entertainment took place, art would lose all pretensions to universalism and idealism, along with any justification for state subvention.

For Marx the commodity is a strange and complex thing, being at once a material object valued by its buyer because it has a use and, because of the action of the market, a bearer of monetary exchange value. While uses are diverse and incommensurable (a coat hanger is of no use to me if I am thirsty), exchange values are all set on the single scale of price. Benjamin Buchloh argues that use-value is increasingly surrendered, and art (like money) has become a commodity of nearly pure exchange value. (As long as they remain material objects, incidentally, neither money nor art can shed all use-value; as Mayakovsky recounted, during the Russian Civil War books were printed on money that had gone out of use; while, in Duchamp's infamous provocation, a Rembrandt could be used as an ironing board.) In a further stage, even the pretence of achieving use-value in art is dropped, as artists simply reflect and examine the new scene in which there is no distinction between art and money, and do so without critique or the desire for change.

It has become a standard tactic in Western contemporary art to refuse to take sides in a work, or when commenting on it. The model here is Warhol, of course, who talked and wrote a lot but only in words that issued from his branded persona, so that no one could be sure of their status: 'Being good in business is the most fascinating kind of art.' As art draws nearer the standard commodity it would be foolish to expect critical comment on a product by its maker. So in Bijl, Beecroft, or Fleury, it is unclear whether the fashion industry and consumerism are celebrated or condemned. Such works highlight the existence of commodities or models by making them seem strange, above all by altering the environment in which they are seen. Yet, despite the artists' and critics' statements that surround this work and assure the viewer of its neutrality, the ambivalence is far from complete. Such work

is modest and weak if taken as critique, strong and strident if taken as celebration, since after all—particularly in the work of Fleury and Beecroft—what is glossily and cannily produced is another set of commodities, and the publicity and sponsorship arrangements through which they are seen and sold. To consume these goods, bearing the tinge of a critique of themselves and their consumption, is the very definition of 'camp', which Susan Sontag argued long ago is the tactic intellectuals employ to sanction their enjoyment of mass culture.

Yet there are disturbances to this simple scheme of art and other commodities growing closer in character, as are galleries and shops. The materiality of the art object persists, even for video and media art, which has generally been accepted as art only by paying the price of becoming embodied in installation. The art market is still dependent upon the buying and selling of rare or unique objects far removed from the mass-produced commodities found in ordinary shops. In most markets a few dominant companies control production, but there are few in which consumption is regulated. The commercial art world tries to hold both reins tight, for the buyers of these objects are still relatively few and known to the sellers, production is often artificially limited, and patronage often has a personal dimension. For Dave Beech, these glimpses of older, even pre-industrial systems of commerce are partly the guarantor of art's distinct cultural value. As we shall see in Chapter 4, however, a concerted modernization of the art market has put these values under severe pressure.

Above all, while ordinary commodities live or die by millions of individual decisions to buy or not to buy, the feedback mechanisms which determine the trajectory of contemporary art are regulated and exclusive, and the ordinary viewer of art is permitted no part in them. Vitaly Komar and Alexander Melamid highlighted this issue by applying the standard methods of the consumer questionnaire to painting, producing results that cater to the average of different national populations. The results were a

14. Komar & Melamid, *Finland's Most Wanted*, 1994.

series of hilarious and surprisingly uniform paintings, in predominantly blue tones, in which charismatic animals and famous historical figures populated idyllic landscapes, optimal for human survival (Figure 14).

From the moment it was established, the safety of art's enclave has, of course, been challenged by artists. This was part of the point of sticking newspapers to canvases, trying to put signed and dated urinals into galleries, or—more radically—making art act as the servant of mass production. Yet while those challenges were tied to time and context, the objects in which they were incarnated were not, and as they persisted through history, their tinge of radicalism reinforced their aesthetic lustre and market value alike as they became increasingly conventional art commodities.

As mass culture became steadily more spectacular and immersive—with larger high-definition TV sets and vast cinema screens, with the enclosed and carefully calculated spectacle of the shopping centre or theme park—art had to compete. It could do so, as we have seen, by feeding off the allure of mass culture while

adding its own aesthetic and estranged edge. It sometimes competed by reversing the norms of mass culture: to take much early video as an example, it produced slow, portentous pieces without camera movement, narrative, or obvious meaning, to set against the standard moral tales and visual incident of TV. It could also provide impressive, non-functional objects and environments that, unlike those of the shopping mall or resort, were not geared to selling (or at least not to the vast majority of their viewers). Last, it could make representations of a scale, richness of colour, and definition unknown in the mass media.

This last tactic has produced some of the most commercially successful work of the 1990s and beyond: large-scale colour photography. Not merely a highly successful commodity, it has also regularly commented upon consumption and production. Such photographs, made with large-format cameras, printed to the scale of grand Salon painting convey visions of the contemporary world which have a startling clarity and depth of colour. They tend to be produced in small editions and at different sizes, making them as suitable for the museum as for the collector's living room. In the recession of the early 1990s, museums looking for spectacular and accessible works bought many of these pieces, and their prices began to climb steeply as a result. In 2002 a large Andreas Gursky, one of his Prada trainer series, was sold for over £400,000 (then about US$600,000) at auction, a record for a contemporary photograph at that time; in 2011, his *Rhine II* (1999) was sold for US$4.3 million, a record for any photograph sold at auction.

An art-historical line that may be traced back from the heights of the most successful German art photographers (Gursky, Candida Höfer, Thomas Ruff, Thomas Struth) back through their teachers at the Düsseldorf Kunstakademie, Bernd and Hilla Becher, and through them to that extraordinary ethnographer of the Weimar Republic, August Sander. It can be interpreted as beginning with

Sander's belief in the power of photographs in long, comparative series to convey social knowledge in a highly dynamic, uncertain, and dangerous situation, through the Bechers' strange serial mourning of the built forms of industrial modernism to, say, Ruff's insistence in his 6-foot-tall passport-style portraits on the medium's inability to convey anything meaningful, no matter how much detail it throws at the viewer. Tracing that line in the gallery (rather than in reproductions) something else is obvious: Sander's black-and-white prints were finely made, and little larger generally than a hand; the Bechers, too, worked in black and white and printed at different sizes, often mounting their prints in grids in a single frame to create a work that is 4–5 feet across; the work of the next generation bursts into rich, saturated colour and for the most part massively outgrows its predecessors. The largest Gurskys and Struths, up to 4 metres on their longest edge, allow the viewer to step right up to them, so as to examine their serenely grain-free surfaces and myriad details. In their scale, production values, self-conscious gravity, and expense they appear as the new history painting, and, like history painting, they were made primarily for the museum.

Much of this work has increasingly paraded its artiness: Struth's early street scenes turned Sander's eye and technique on the physiognomy of the city in modestly scaled, subtly composed, black-and-white pictures; Gursky's took the casually framed, washed-out look of old amateur photographs and applied them to banal holiday scenes and bored spectators. This work also reflected variously on the legacy of modernism. Ruff has taken pictures of buildings by Mies van der Rohe, draining them of bright colour to give them a faded look, accentuating the ageing of the buildings; or he has dully colourized old photographs (e.g. of a landmark exhibition of Jackson Pollock at the Whitechapel Gallery in 1958) to similar effect.

Struth and Gursky documented the system-built structures of industrial estates, office complexes, and the leisure industry. As

their work developed, the art-historical references have widened. Both Gursky and Struth now leave the viewer in little doubt about what they are seeing: their sumptuous productions frequently refer to painting, and they sometimes take the gallery itself as their subject-matter. Both have had shows in New York's most important art museums—Gursky at the Museum of Modern Art in 2001, and Struth at the Metropolitan in 2003. The exhibitions and their catalogues put the seal on photography's graduation to the pinnacle of art, and the texts (particularly Peter Galassi's on Gursky) made more reference to parallels in painting than photography. Art is thus ratified by reference to other art, and photography is remade as a spectacular creature of the museum.

Marx argued that production and consumption are bound together to the point of unity. Not only does one depend upon and complete the other, but production always involves consumption (e.g. of raw materials), and consumption production (eating sustains the labouring body). The focus on consumption in much of the art world flows from the prominence of advertising and other corporate propaganda, for which the less consumers think about production (who labours and for what pay, in what circumstances and at what risk, under what form of coercion, with what environmental consequences), the better. This blindness is reinforced by the art world's own archaic production practices, which separate it from the regular business of mass production. There are huge numbers of art works that have dealt, for instance, with the uncanny character of toys in the realm of consumption (to take some varied examples, in the work of Danielle Accossato, Martin Honert, Mike Kelley, Mariko Mori, and Georgina Starr); few touch on the equal charge of the contrast between their intended use and the conditions in which most of them are made—in China, say, by the harshly disciplined labour of young women who shuttle between unsafe factory and crowded dormitory (an exception is Michael Wolf's *The Real Toy Story*, shown in Hong Kong in 2004).

There are a few artists who bring the fields of production and consumption into connection and contention. Gursky's photographs, of shops and galleries as well as factories, examine the cultural rather than the economic unification between consumption and production. His depictions of, say, a Grundig factory, the Pompidou Centre, and a 99¢ thrift store show muted human figures dominated by large-scale grids. These can act as textbook illustrations to Theodor Adorno's arguments in his essay 'Free Time' about the secret affinity and interdependence of work and leisure, in which leisure, only apparently partitioned from work, adopts work's structure and forms.

In the last decade, however, there has been a sea change in art's character, and in its relations with consumerism and mass culture. The rise of social media has brought about a transforming, and intensely modernizing, turn, opening art up to quantifiable and manipulable instant feedback. The games of social distinction are now played across those media, and art works are incessantly recorded and shared, commented upon and recirculated. In David Joselit's analysis, the aura of the exhibited works has been replaced with a new criterion for judgement, the ease with which it circulates, generating the 'buzz' of publicity. In a cultural activity that has a strong affinity with Warhol's depictions of his confected social scene, users splice their artistry and a display of identity as they snap and share images of art, sometimes in the hierarchical scramble for digital distinction, or in a tongue-in-cheek performance of stylistic conformity. The ready-made Instagrammable work—especially anything in this narcissistic age that incorporates mirrors—is looked upon with a cynical smile. Lee Bul's *Via Negativa* (2014), a mirrored maze reflecting lights and viewers in infinite repetition, is the perfect honey-trap for those yearning after selfies, as are Kusama's lavishly lit and reflective Infinity Mirror Rooms. Michelangelo Pistoletto, veteran artist of Arte Povera who had been working with mirrors since the 1960s, found himself borne to renewed fame through a performance in the Venice Biennial in 2009 when he shattered

various of his mirror works with a hammer before the opening crowd and the world's media.

All this is another and intensified consumerism, in which experiences are packaged up into reproducible parcels to be relayed, spied upon, and put to immediate use—those of their authors, and more saliently those of the social media companies. In the process, the physical objects that sometimes form the origin point of this network of effects rippling outwards are profoundly altered, hollowed out to become mere skins, and increasingly the props and stages for social performance. In a famous critique of 1967, Michael Fried condemned what he called 'theatrical' work—that is, pieces that mug knowingly at viewer (and camera) and depend upon their response, rather than existing in their own self-contained and self-absorbed world. It could be argued that theatricality, always difficult to exorcise, has become the default condition of art in the social media age.

We have seen that for Dave Beech, a key way in which art resists becoming a commodity like any other is that it is very often 'consumed' or experienced without being sold. Social media places this refuge from the commodity relation under threat, as the act of experience is parcelled up into quantifiable and manipulable portions of data thrown across the web for the purposes of self-advertisement, and serving the ends of data-mining.

Two apparently similar photographs by Gursky point to the change—*99 Cent* (1999; Figure 15) shows a scene very similar to Bijl, in which cheap commodities are digitally altered to play up their uniformity and arrangement by colour in a budget supermarket. The products are reflected in the ceiling (upside down, as in Marx's camera-obscura model of ideology), and the arrays are left undisturbed by the occasional customer. In *Amazon* (2017; Figure 16), an entirely unpeopled warehouse scene shows a vast array of commodities, apparently jumbled together without graspable order. Only the slogans on the pillars (Work Hard, Have

15. Andreas Gursky, *99 Cent*, 1999.

16. Andreas Gursky, *Amazon*, 2017.

Fun, Make History) point to the existence of a workforce that is poorly paid, insecure, and constantly spied upon to ensure that they stick to time and quota. The commodities are ordered, though, by algorithm in a continual calculation of orders going in and out and available shelf space. The workers cannot grasp that order, and do not need to, being fleshy automata who are ordered to a numbered location by the machine. The photographic sublime has shifted from the unknowable character of the commodity to the unknowable calculations of the algorithm.

Chapter 4
Uses and prices of art

As long ago as 1968, in a lecture given at the Museum of Modern Art in New York, the critic Leo Steinberg argued that avant-garde art, newly Americanized, was coming into close alignment with big money: modernism was a speculative stock, and quality had become 'market attractiveness'. He predicted that before long 'mutual funds would appear based on securities in the form of pictures held in bank vaults'. Back then, contemporary art was still settling into its accommodation with money as the market outgrew its old condition as a tiny and specialist area, and there was brief wonder at the resulting change of scene. This passage, read over fifty years on, has the peculiar quality of being both surprising and familiar. In the long settling that followed, the association of art and money was less remarked upon, and a shyness crept over dealers and critics alike, as if the relation, too clearly spelt out, was dangerous. Those artists and critics who had the temerity to highlight it (such as Lee Lozano with the embarrassing and revealing offer of free money to her studio visitors) ran the risk of being thought vulgar, materialist, and overliteral.

Things have switched back again now. Since the early 2000s, strong modernizing forces in the contemporary art market brought money back into clear view and unabashed discussion. We will fix upon these forces throughout this chapter, but for now

we should look at the system as it was, to understand the current contrast. Both making and selling are unusually controlled in the contemporary art market. Dealers may sign exclusive contracts with artists who are then encouraged or instructed to produce particular kinds, sizes, and numbers of work: how often has one seen in commercial galleries decorative and wall-bound spin-offs of some apparently recalcitrant anti-commercial installation? For obvious reasons, these urgings usually remain secret. Buyers are vetted for their commitment to collecting, since it can be dangerous to an artist's reputation or even to the market as a whole to have a sudden and unexpected sale of work. There is less regulation in the so-called 'secondary market' of the auction houses, but even there the market is hardly free. Aside from scandals about systematic price-fixing, reserve prices are set below which works will not sell, the house itself quietly buys in works that fail to reach an acceptable price, and bidding is manipulated by collectors, dealers, and speculators. One innovation, much used recently, has been the guarantee, under which a would-be buyer secretly agrees to purchase a work at a set price should the auction bids not exceed it. Since both the agreement and the price remain secret, it is an insider manipulation of an apparently open market.

When art was produced using craft methods, the supply of any artist's work was unavoidably restricted, and if demand for that work was high, then prices rose. There are still many artists who create value through the expenditure of large amounts of manual labour (their own or more often their assistants') on unreproducible objects. Yet as through the 1990s more artists came to use technical and reproducible media—above all, photography and video—the restriction of production came to seem increasingly artificial. The situation gave rise to some very odd ways of making things. Works that look like traditional art objects, might not be: for example, Jeff Koons (Figure 17) takes various commercial images, collaging and altering them using a computer. When this process is complete, a giant print-out is generated which is then handed to Koons' assistants who (as

17. Jeff Koons, *Loopy*, 1999.

Robert Rosenblum puts it in the Deutsche Guggenheim catalogue) 'with the clinical accuracy of scientific workers' make a saleable rendering in oil on canvas. It is the most manual but mechanical stage that assures the status of the piece as a unique

work of art. This way of working was merely an early instance of the integration of digital processes into fine art production of all kinds, including the mass production of paintings that goes far beyond the old studio workshop using apprentices and assistants.

The limit placed on supply makes the art market highly unusual, so much so that many economists have been reluctant to explain it using their standard terms. Ideally, according to classical economic theory, in shopping for (say) a tin of soup, price is matched against the buyer's desire for the product; similar or identical tins can be found in different places and at different prices, and those prices fluctuate with supply and demand. As Neil De Marchi describes the situation in a book on economists' thinking about the arts, little of this applies in the art market. Fashionable taste, not use, has a large effect on demand, disrupting the usual relation between utility and desire; many works of art are unique, disrupting the laws of supply, which become an all-or-nothing affair, so no equilibrium is established as demand and supply respond to one another. Worse, in buying a unique object from a monopoly supplier, since no comparison with other objects is available, there can be no reliable market information about the deal.

In fact, the situation is a little more mundane: many art works are unique but this does not mean that they are not compared by dealers and buyers with works that they deem similar—most notably, works by the same artist, though size, expense of materials, and the labour that has gone into a piece are also taken into account. Auction prices may be far from pure indicators of market judgement, but they are at least sometimes at variance with the prices set by dealers. Nevertheless, the market does remain short of information (much of it is kept secret), supply is regulated, demand managed, and pricing is highly susceptible to fashion and circumstance.

The art market may be peculiar for buyers, but it is equally odd for producers. Hans Abbing has reflected on the oddity of the mismatch between art's status and economy, which condemns the great majority of artists to poverty. While the status of the profession is high (in part because it stands a bit apart from the regular run of commerce) and the incomes of a tiny number of successful artists are astronomic, the overall nature of the art economy is generally disavowed by the would-be players. Artists are singularly ill-informed about their prospects for success, are prone to taking risks, are poor but come from wealthy backgrounds (an anomaly in the general economy, since most poor people have poor backgrounds, but one does not have to search far for the reason for it), and tend to subsidize their art-making out of other earnings. These factors, along with state subsidies, claims Abbing, cause the art world to be permanently overcrowded, making the poverty of artists a structural feature. (In the UK, the number of fine art students going to college each year has nearly tripled between 1981 and 2006, far outstripping the general rise in student numbers, and the rise continues. In the US, over two million people declare themselves to be artists in the national census.) The poverty of artists contributes to the status of the arts, for the few successes should be seen to be picked from a vast pool, and all artists should be seen to risk destitution in their pursuit of free expression.

Art's autonomy

This scene, semi-detached from the regular run of commerce, has been one basis for art's supposed and now threatened autonomy. The autonomy of art has been powerfully described by the sociologist Niklas Luhmann, in his book *Art as a Social System*, who compares it to other functional systems in modern society (such as science, politics, and law). It has the same tendency to 'operative closure', a drive to discover its own function and to focus on it alone. For Luhmann, art's exclusive feature is that it uses

perceptions, not language, and is thus separated from mundane forms of communication. Its role may be to integrate the incommunicable into the communications networks of society. (We shall see later that as a description of recent art, at least, this account has to deal with the problem that the gap between the two seems to be lessening.)

For Luhmann, the more art tries to immerse itself in the general run of products and discourse in society, the more it ends up reinforcing its autonomy:

> No ordinary object insists on being taken for an ordinary thing, but a work that does so betrays itself by this very effort. The function of art in such a case is to reproduce the difference of art. But the mere fact that art seeks to cancel this difference and fails in the effort to do so perhaps says more about art than could any excuse or critique.

Yet the art system does have distinctive features: participation in it is optional (which can certainly not be said of economics or law), and it inspires only a low level of participation (about half of the British population, for example, are not museum-goers). Its means of inclusion and exclusion are independent of those of other systems, and it is a comparatively isolated field of activity (again, for example, the connection between politics and law is very close).

Luhmann's account is a systematic but ideal description that discounts the effects of class and distinction, and of market and state pressures on art. We can be more specific, for example, about who participates: Bourdieu and his collaborators' extensive sociological study *The Love of Art* examined the museum- and gallery-going habits of Europeans, bringing out forcefully how much such activity was determined by education. Simply put, more educated people are more likely to go to galleries, feel more comfortable there, stay longer, and are more able to talk about what they have seen. While visiting galleries and museums to see contemporary art has become far more popular than in the

mid-1960s when Bourdieu made his study, education still strongly correlates with the love of art.

Nevertheless, Luhmann's book also fixes upon the actual autonomy of art, which paradoxically accounts for its connection with and use to other systems. That autonomy, far from being illusory, is central to art's ideological function, and is maintained by art's various institutions, including academia (art schools, art history, and visual culture departments), museums, and professional bodies. The art promulgated there is sometimes at odds with that which achieves success in the market.

Howard Singerman's fine account of the development of art as a university discipline analyses the effects of this institutionalization on art's practice and products. Universities work to separate professional artists from Sunday painters, and do not expect of art students that they be manually skilled, take recreational pleasure in their work, or wrench it from their tortured souls. Rather, they must produce a distinct and certifiable knowledge, in a theoretical and esoteric language, guaranteeing the exclusivity and status of the art profession. Artists are not only trained in universities but sometimes come to inhabit them—as part-time teachers, or as touring performers accompanying their work. The art of the academy which Singerman compellingly describes—comprising video, film, and performance—often requires the presence of the artist to accompany and explain the work, appeals to academic audiences, and is built on grants, fellowships, and residencies. This escorted art may sell, but it achieves an independence from the commercial market, since the artist's time is more often purchased rather than any resulting object. It, too, achieves autonomy from the general run of mass culture, at the price of adapting to another set of institutional concerns, those of the increasingly audited and professionally administered university. Its main purpose is to generate dialogue among professionals, but the effects are far broader than that, influencing much of the discourse around art.

The first effect is that for there to be an art department there must be a unified and bounded thing, called 'art'. The second is that it can be researched, and that much of what artists do can be described as research. The third, that the field requires description in a specialized language, the acquisition of which defines art professionals. All these effects tend to produce an art that talks most effectively to art insiders, and seals out the wider public.

This autonomy is not static, unitary, or unchallenged. The specialist world that serves the markets is quite different from that connected to academia. To get a rough-and-ready understanding of this, contrast two prominent models—the magazine *Flash Art* (look at the quality of its paper and colour reproduction, the number and character of the adverts it carries, the accessible style of writing) to the journal *October*, with its restrained visual style, monochrome illustrations, complex, elevated prose, and arcane theoretical canon.

Furthermore, the professionalization to which academia aspires is directed against a cultural populism encouraged by the state and—to a limited degree—by business. Highly trained museum professionals, who have spent years arduously acquiring specialist art-world discourse, are enjoined to lose it when communicating with the public, as art institutions strive to be inclusive. There is a clear tension between art's professional discourse and its wider functions and ideals. If professionalization is pushed too far, that would again undermine art's claims to universality (and thus the reasons for its protection). If accessibility and instrumentality were pushed too far, art's distinctness from the rest of the culture would erode with similar results.

Besides these general tensions between different models of autonomy—brought into existence by the market, the university, and the museum—there are more specific recent forces that threaten to dissolve the fabric of art's autonomy: the

modernization of the art market, and the competing demands, promulgated by the state and business, that art should be put to use.

One factor which has greatly affected the market is corporate collecting. This is a fairly recent phenomenon, as the vast majority of such collections were founded after 1945, and most since 1975. Some of the consequences for the trajectory of contemporary art are laid out for an earlier period by Alexander Alberro in his remarkable book about the marketing of conceptual art at a time when corporate collecting was first becoming important. Corporations collected innovative art that would favourably reflect the values that they wished to project—especially of creativity and entrepreneurialism. While it had been a small-scale activity, separate from the general running of a business and often dependent on the interests and tastes of individual executives, corporate collecting has lately changed. No longer geared merely to finding something decorative to hang on office walls, among large corporations collecting is integrated into the business plan and is designed to fit the company image. Nevertheless, Chin-tao Wu's account of corporate collecting argues that there is still a preference among businesses for flat, decorative works that do not risk controversy over social, political, or religious issues. These works, after all, are intended to be seen in a setting that is neither fully private nor public.

Collecting is also explicitly tied to the character of the neoliberal firm. One notorious example is UBS, sponsor of the Basel Art Fair, in its transformation from a bank mostly serving merely rich business people in Switzerland to become a lean, global mega-brand serving the super-rich who are courted at the fair. In the process, tens of thousands of workers were sacked—so many that the company initials, it was widely joked, stood for 'U've Been Sacked'. Such ruthlessness was set against the development of the brand, to which art collecting and art sponsorship were an integral part.

Once again, it is difficult to assess the impact of corporate collecting on contemporary art because most dealings remain secret. We can guess that corporate art collecting accounts for a considerable volume of contemporary art sales, but it is hard to know just how much because art buying is often included in public relations, building, or furnishings budgets. Wu cites a 1990 study that claimed that in the US about 20 to 30 per cent of the market in New York was comprised of corporate collecting, and outside the city about half. It is likely that the sheer volume of this instrumental, institutional buying contributes to the modernization of the market.

Another factor is the growing number of the super-rich who buy contemporary art. For decades, even in the postwar period, only a tiny minority collected the abstruse and sometimes rebarbative offerings of avant-garde artists. Contrary to widespread public perception, fixed on fantastic prices for major works achieved at auction (a perception that is, of course, much fostered by the auction houses themselves), art was not generally a good investment, certainly not over the long term, performing consistently worse than stocks and shares. Speculating in low-priced contemporary art remains a very risky investment, especially when the costs of storage, insurance, conservation, and the dealers' or auction houses' commissions are taken into account. A salutary exercise is to take a look at covers of old *Artforum* magazines: while gaining such a cover image is a sought-after accolade, it is surprising how many of the once valued and vaunted artists who have graced its covers have since passed into deep obscurity.

In 1992, Peter Watson gave a detailed account of art's economic performance, and argued that investment only made sense over the short term as a high-risk speculation, and that large amounts of money are only made when art is sold during one of the market's spectacular booms. Unsurprisingly, then, buying art

which is already highly valued was almost always a bad investment. Studies of art investment before the turn of the century generally showed that they performed about half as well as other types of speculation. This was the price paid for owning art, and it explained why relatively few wealthy people collected. Of those that did, many collected for pleasure and prestige as much as investment.

Much changed in the art boom of the early to mid-2000s, and for three main reasons: first, that stocks and shares failed to perform well, an effect that would be greatly exacerbated by the financial crisis. Lacklustre growth meant investment opportunities were reduced, the bets on future growth seemed less secure, and people with money to spare wondered where it could be productively invested. Second, by comparison, you could make money more reliably out of art, as funds flooded into material assets (land, buildings, and resalable luxury goods). The price that had been paid to own art, which was a basis for its social cachet, has been reduced or eliminated. Third, and in concert with a general trend to financialization in all business, art investment became quantifiable and (it was claimed) increasingly predictable. Just as other businesses that made material products, such as cars, became increasingly involved in financial speculation, so much so that it could become the major part of their transactions, so it was in the art world. There are various models for the evaluation of art investment, all of which have their defects, and some of which tend to exaggerate the likely profits. One of the best known is the Mei Moses, released in 2001 and later acquired by Sotheby's. It relies on repeat sale of the same work to track changes in value. Since many works are resold rarely, if at all, its data are skewed towards those that are; and this in itself overemphasizes works that have yielded a good return. Even so, as financialization took hold, art approached the condition of that most abstract of commodities, money—and it is actually used like that by the rich, as a quasi-liquid form of speculative capital. Beyond that, as we

shall see, artists—especially those who showed regularly at art fairs—tailored their works to assist the predictability of the models.

Art has become a standard investment, part of the portfolio of the super-rich, used to spread risk, and engage in tax avoidance. As Georgina Adam shows, in her book *Dark Side of the Boom*, art has various advantages for those wishing to engage in corrupt or dubiously legal financial practices. As cash has come under increasing scrutiny, art has taken its place as a portable, lightly regulated asset that can be easily bought and sold in different currencies. The very difficulty of knowing its precise value offers opportunities for corruption, as the Japanese manipulators of the 1980s knew very well. Hidden in purpose-built art depositories in free ports, works can change hands many times without physically moving, away from the eyes of any state and its tax inspectors. No one knows for sure what is locked up in such vaults—secrecy is a large part of their attraction—but given the astonishing size of these facilities and the precipitate growth of the storage industry, some estimate that far more art is warehoused in this way than displayed.

To a degree this explains why the collections of the super-rich display such orthodox tastes: what might, one would think, be a chance to display individuality instead becomes an exercise in the acquisition and display of objects of assured value. Yet the super-rich tend to inhabit a conventional world, in which competition for the same artists' work, the same luxury goods, and the same select band of interior designers is *de rigueur*. Adam quotes a 2013 Christie's sales blurb for a 10-foot-high *Balloon Dog* by Koons: the work, it claimed was the

> Holy Grail for collectors and foundations […] and has always communicated the prominence and stature of its owner. […] To own this work immediately positions the buyer alongside the very top collectors in the world and transforms a collection into an unparalleled level of greatness.

The sculpture sold for US$52 million to New York collector David Zwirner.

The art world is one arena for the global super-rich elite to pursue their conspicuous expenditure. Their increasingly extravagant ways of marking themselves out from one another with gigantic yachts, private jets and helicopters, and vast mansions are of a piece with the love a proportion of them profess for art. As critic and curator Joseph Backstein wrote of the rise of the Russian collector: 'What is a rich Russian? It means you must have an apartment in Moscow, a Bentley, a dacha on Rublyovka, a house in London, a villa in Sardinia, and a yacht. Then you must buy modern art.'

Sarah Thornton describes the hundred private jets that touch down in Basel for the art fair, and the fine gradings of socio-cultural rankings among those jostling for position at Venice, where for some dealers the poolside of the Hotel Cipriani is their informal office. What is purchased through participation in the art world, through collecting or patronage, is not merely stuff but access to an elevated social set, larded by an ersatz intellectual discourse, and a social cachet in which wealth is leavened by high culture—this is Bourdieu in practice, a scene in which cultural and material distinction come into an apparently natural symbiosis.

Unlike many of the merely rich collectors of avant-garde or conceptual art, the new collectors are neither particularly informed about art and its history, nor unconventional in their tastes. What do collectors buy, largely at the art fair and the auction? In the US, most of the best-selling artists make highly accessible work; and some, in a backwash from the current popularity of street art, are associated with graffiti's first (brief and ill-fated) flush of success in the galleries—for example, Michel Basquiat and George Condo. The most successful contemporary artists in 2015–16 by turnover at auction are (in order): Michel

Basquiat, Christopher Wool, Jeff Koons, Richard Prince, Peter Doig, Yoshimoto Nara, Rudolf Stingel, and Keith Haring (with Basquiat and Koons leading the prices for single works over a number of years). All are male, most indeed are white males of a certain age and swagger, and most are branded. The dominance of street-art or street-art-derived work is striking, as is the fact that none of these works is likely to leave you creasing your brow for very long. This snapshot of the heights of the market shows an aspect of the art world that is very far from its usual view of itself as liberal, non-conformist, open to women and people of colour, complex, and deconstructive.

The male bias of the artists faithfully reflects that of the buyers. With the exception of an occasional heiress, the super-rich world is an overwhelmingly male domain. As Chrystia Freeland recounts, they also tend to live in highly patriarchal arrangements in which their wives—while they may have a say in art acquisitions—rarely work. Ally this to their conservative economic and political views, which usually encompass a finely honed contempt for the poor, and their tastes become less of a puzzle: these self-styled 'masters of the universe' buy art that offers them an ideal mirror view of themselves.

Even when an ideology of macho elitism is not directly at play in the work, price has its own allure. The relations between art's aesthetic and monetary value are deeply fraught, and most theorists want to say that while there is some relation, for example, between the aesthetic worth of a Rembrandt and its price, it cannot be reduced to one of identity. An exception is the nicely scandalous position of Wolfgang Ulrich, in which he declares that art's allure is simply that of money, that high prices alone induce 'lofty feelings', and even the sensation of the sublime in the mismatch between material object and market value. If this is really the case, a market crash will cause a sudden decline in aesthetic feeling!

Another sign of modernization is the move of the major auction houses into the area of contemporary art. They have produced exhibitions, curated by respected figures and accompanied by weighty catalogues, as a way to bolster contemporary work that later comes up for sale. They have also emulated artist-run 'alternative' spaces by putting on shows in disused industrial buildings, and have even purchased dealerships. These moves have been successful, in part because artists see an advantage in breaking the monopoly of the dealers. In a signal move, as the 2008 crash began, Hirst bypassed his dealers to make a huge sale of his own art work at Sotheby's: it made over £100 million, burning the eager buyers who were to find that the unfolding financial crisis trashed their investment.

As elsewhere in the art world, the scene is dominated by the big companies. Sotheby's and Christie's together account for 80 per cent of the top end of the market. In contemporary art, they had over half the sales at auction, sharing about US$800 million in 2013. While this is a small percentage of the overall market when compared to the dealers, as Adam points out, they have been a major driver of art market growth, especially by creating and stimulating demand in emerging economies.

The galleries needed a competitive market space from which the auction houses could be excluded, and their response was the art fair. It has become a prime playground for the super-rich in their hunt for social kudos. Money-rich and time-poor, they generally lack the leisure, inclination, and education to seek out art where it is made and locally displayed. The global art fair round that had its origins in Basel in the 1970s has grown vastly, especially since 2000, when the number leapt from dozens to hundreds, and has come to take in about a third of the entire market. Once again, it is extremely unequal with three brands dominating the top end: Basel and its various outcrops (Miami and Hong Kong), Frieze in London and New York, and TEFAF in Maastricht (which deals

more in older art). As in the gallery world, middle-ranking fairs, even those of substantial size such as Madrid's ARCO, have been finding themselves in financial difficulties.

There is a marked hierarchy within the fairs, too: in the competition for inclusion, gallery space, and location, in the graded VIP passes and invites to social events and exclusive early openings. As major galleries attend five or more fairs each year, and require fresh work for each, the demands on artists have increased, with new work being required every couple of months or so. Many artists have responded by making work in editions, or by making large numbers of standardized 'unique' works, painted by assistants.

A further reason for standardization is to assure investors that what they are buying has a provable value. We have seen that the value of unique goods, rarely sold, is hard to measure, and it is also highly subject to the vagaries of taste (one of the lessons of Gerald Reitlinger's pioneering books on the art market was that the favourites of the past were rarely honoured in the present; for example, in the 18th-century favouring of Gerard Dou far above Frans Hals). If a dealer can point to a very similar work, or better a series of them, which has recently sold so as to track rising value, buyers will feel that they are taking less of a risk. This standardization greatly adds to the feelings of ennui at the art fair, as works of art become more like tins of soup.

Modernizing forces have helped to create a type of dealer-collector, who buys for speculative investment, often outside the usual run of galleries—through auction, from artists or from other collectors. In the UK, Charles Saatchi is the most obvious example of this type, since he deals in art for speculative purposes and his art collection is linked with his corporate finances. He is well known for buying directly and cheaply from artists or even degree shows. He runs a private museum, which ramps up the value of

his holdings, and also reduces his exposure to tax. While such practices were controversial in the 1990s, they have since become standard practice for many of the wealthiest collectors, many of whom act with equal ruthlessness. Since 2000, hundreds of private museums have been established, which offer their owners preference in buying the most sought-after works, tax breaks, bragging rights, and may well boost the value of the collection. The acquisition budgets and increasingly the scale and architectural quality of these museums put public institutions in the shade: for example, Eli and Edythe Broad's US$140 million museum in Los Angeles houses their collection in a signal building by Diller Scofidio + Renfro, attracts millions of viewers a year, and encompasses its own plaza.

Uses of art

There are other challenges to art's autonomy of apparent uselessness alongside its modernized investment use. The supplementary character of art to neoliberalism is becoming more visible as both corporations and states, aware of the lack in free trade, attempt to augment it by making instrumental demands on art. Corporations want to use art to assure an attachment to the brand that cannot be purchased by advertising; some states have wanted to heal the destructive effects of free trade on social cohesion (such as the Labour government efforts in the 1990s), though many of these efforts foundered after the financial crisis. Both, then, are attempting to counter the very forces that they jointly set in train. Even rich states face the social breakdown caused by increasing inequality, driving many into poverty and insecurity, and pressing on the middle classes that sustain the whole system of consumerism. We have seen that Naomi Klein has argued that the 'outsourcing' of production to developing countries is connected to the ever greater emphasis on the logo and the brand. As part of this obsession with brand image, corporate demands on art have become more widespread and systematic.

Business has moved from occasional charitable sponsorship of the arts to building partnerships with museums or artists in which the brand of one is linked with the brand of the other in an attempt to inflate both. They have turned increasingly to collecting and commissioning art, exhibiting it, to curating exhibitions held in public venues, and in some places founding corporate museums. For example, Leeum, the Samsung Museum of Art in Seoul, is a massive array of extravagant spaces, divided into three distinct zones designed by Mario Botta, Rem Koolhaas, and Jean Nouvel. It outshines the city's state museums. The series of Absolut adverts, paintings, or objects reproduced as magazine pages, which forge a brand alliance between artist and vodka company, was fittingly launched by Warhol in 1985. Many prominent artists, including Louise Bourgeois, Keith Haring, Ed Ruscha, and Vik Muniz have made them. While these pieces made the relation between artist and corporation particularly transparent, the series was terminated in 2007, when its distinctiveness was lost as other alcoholic drinks' companies launched similar operations. When the company was sold, the collection did not go with it, but was decanted into a private museum. As we have seen, artists have frequently teamed up with fashion houses to produce luxury goods. Occasionally, advert and art work merge completely: Takashi Murakami's video, *Superflat Monogram*, is an entertaining update of *Alice in Wonderland*, in which a girl, searching for her lost mobile phone, floats in a dizzying world of Louis Vuitton logos. It is a thoroughly hybrid item, being both elongated advertisement and an animation in Murakami's signature style. It was shown in the first room of Francesco Bonami's painting exhibition for the Venice Biennial in 2003, and also at Louis Vuitton's flagship stores worldwide, to boost the sale of Murakami handbags. Such alliances of artist and corporation help both to achieve 'brand spreading' through the propagation of their PR in the media and the widening of the products that can be sold, from tea towels to limited edition prints.

Corporate involvement in the arts was long a murky area, shrouded in confidentiality agreements and intermittently illuminated with the bright flashes of celebrated and censored works by Hans Haacke that examined the corrupt dealings of art sponsors or the business activities of museum board members. We are now fortunate to have two major, detailed accounts of corporate engagement in the arts by Chin-tao Wu and Mark Rectanus, both of whom have had to write their work in the face of the secrecy that surrounds the subject. Neither the arts institutions nor the sponsoring corporations are anxious to reveal the details of their arrangements with one another.

Wu's account charts the privatization of art, particularly in the UK, where state funds were withdrawn from museums and other arts institutions. The Conservative government led by Margaret Thatcher set out to transform the uncomfortably political character of contemporary art by making it more reliant on market forces. Likewise, Ronald Reagan personally supported corporate involvement in the arts from, among others, oil and tobacco companies.

Sponsorship and other longer term deals with art institutions have obvious and quantifiable benefits for corporations. There is an appeal to potential customers who are otherwise hard to reach: art audiences are on average richer and better educated than the general public, and are thus highly valued by companies. There is the further benefit that comes from seeming to be charitable. Many companies that sponsor the arts have image problems, and seek to scrub clean their otherwise dubious reputations with cultural munificence. This was the case, for example, with British Petroleum (BP)'s alliance with the Tate. Similarly, the German tobacco company Reemstma sponsored Documenta IX (1992) to promote West cigarettes through limited-edition posters and packs. Large-scale arts sponsorship can also be used for political leverage. Wu recounts the machinations of the cigarette company,

Philip Morris, a major sponsor of the arts in the US, which opposed—unsuccessfully, as it turned out—anti-smoking legislation in New York by threatening to withdraw all of its arts support from the city.

As both Wu and Rectanus point out, companies get a lot for their money. Since they generally sponsor exhibitions—indeed, the majority of exhibition costs in Europe come from private sources—they garner the publicity associated with these events. Funding of the rest, the unglamorous matters that range from cataloguing collections to maintaining the drains, falls to the state which provides a subsidized infrastructure on which the limited largesse of the corporations depends.

All of this affects the culture directly. Corporations have specific criteria which must be met before they will sponsor. Projects that fall outside them have little chance of being seen, and certainly not in the prominent institutions that rely on corporate deals. Rectanus says that the main criteria are whether the area of cultural activity corresponds to the company's core markets (Nike gets hip young artists to design versions of their trainers but is unlikely to sponsor an exhibition by Rembrandt), whether the show is likely to get good media coverage, and whether the individuals or groups involved are suitable subjects for promotion—and here the branded artist steps to the fore.

The results have already been examined in Chapter 3: despite the rehabilitation of some older figures (particularly unfairly neglected women artists such as Phyllida Barlow, Yayoi Kusama, and Martha Rosler) an emphasis on the image of youth, the prevalence of work that reproduces well on magazine pages and social media sites, the rise of the celebrity artist, and work that cosies up to commodity culture and the fashion industry, thus serving as accessible fare for sponsors. In this commodified merry-go-round, critique dissolves, and for decades, all this was met at best with a cynical shrug of the shoulders.

Sponsorship as corporate competition also tends to produce spectacular, costly works, in which expense is a manifest quality. This conspicuous consumption simultaneously validates artist, museum, and sponsor, and is another force driving large-scale installation, video, and other high-tech displays. As David Joselit points out, through the display of hugely expensive objects, the museum becomes a temple for the worship of money. Furthermore, when large corporations sponsor or make alliances with an art institution, they expect—given their own global reach and expectation of economies of scale—to engage with a transnational culture. This is another regular pressure on art bodies to hybridize their displays.

While Boltanksi and Chiapello argue that corporations have moved closer to art in their inculcation of mandatory creativity, they still wish to elevate themselves by association with that which they cannot embody: the free play of high art. As the now notorious Philip Morris slogan intoned: 'It takes art to make a company great.' Rectanus says that corporate-speak about the arts serves to legitimize the company as having creativity, being a patron, dealer, or at least broker and collector, and as an integral part of the art audience, the community to which the arts should appeal. If art helps corporations in these image-improving activities that increase profits, once again the risk is that if the process becomes too transparent, art ceases to be imbued with the very autonomy that gives it the status to fulfil this function.

As we shall see in more detail in Chapter 6, the contradictions in the system have begun to produce more than cynicism about how the mainstream art world works. The use of museums by oil companies to burnish their brands, while continuing to despoil the planet and bring about ecological catastrophe, have been too much for some artists who have invaded the offending museums in protest. The organization Liberate Tate (Figure 18) made a series of imaginative and spectacular protest performances—which included bringing a massive wind-turbine blade into the Turbine

18. Liberate Tate, *The Gift*, 2012.
© Martin LeSanto-Smith.

Hall as a gift for the collection—that were difficult for the museum to attack or suppress, and eventually forced the Tate to abandon its long alliance with BP. Many prominent art institutions have been embarrassed by their receipt of copious sums from various members of the Sackler family, who had made much of their money from the sale of Oxycontin. This addictive and dangerous drug was mis-sold and mis-prescribed on a vast scale in the US, leading to tens of thousands of deaths annually, and many more ruined lives. In 2019, renowned photographer Nan Goldin, herself a victim, threatened to withdraw her major retrospective show at the National Portrait Gallery unless it turned down a £1 million Sackler donation. The gallery gave in. Once more—as with the tobacco, oil, and even arms companies that were once the unchallenged sponsors of museums—it showed that corporate death-dealing skulked behind the façade of art-oriented philanthropy.

State demands on art complement those of the corporations, for both have similar interests in fostering social calm, cohesion, and

deference in the face of the gale of creative destruction to which the economic system they support continually gives rise. In Britain, the Labour government saw art as a way to boost the economy, particularly in the so-called 'creative industries', as an aid to regional development, and as a balm to heal the divisive social rifts opened up by the long years of Conservative rule. Art was supposed to be of quality without being elitist, and to draw in new, diverse audiences. There were similar moves in the US under Clinton, where National Endowment for the Arts (NEA) funding, long under attack from conservative politicians, was justified on the grounds that art had a role to play in social programmes, including crime reduction, housing, and schooling. The danger of such moves is that in revealing the instrumentality of art, they also unmask with too much clarity the relationship between art and the state, which is supposed, after all, to be founded on idealism and eternal human values. If states fund the arts to improve the souls of their citizens, the effect is ruined if those consumers of art wander about galleries thinking about advertising strategies, gentrification, and regional development. In the rich neoliberal nations, in the wake of the financial crisis, the state has been so weakened that such salves were dropped, being among the first victims of austerity.

Yet elsewhere, the growth of museums worldwide through the 1990s and beyond was without precedent. In China, from 2000 onwards, thousands of new museums were opened in a state-planned doubling of their numbers. Elsewhere in the same period, many new museums opened or established new branches, including Tate Modern, the Chicago Museum of Contemporary Art, the Zeitz Museum of Contemporary Art Africa in Cape Town, and the colossal buildings programmes in the Middle East, which include a complex at Doha, and of course Abu Dhabi's Saadiyat Island, to include branches of the Guggenheim and the Louvre. Adrian Ellis has cogently outlined some of the possible causes. First, museums have always been a way of expressing the prestige conferred by wealth, and that wealth has become further

concentrated—so the rich do what they have always done, but they are richer now. Second, as we have seen, national and regional competition plays a role. Third, new education and entertainment programmes in museums need more space. Fourth, changing leisure patterns mean more museum-going. Last, expansion introduces competition between museums themselves, so that staying the same while all around are growing does not seem an attractive option. This is all the more so because the increasing inequality of the art world affects museums too, and the bulk of the prizes (donations and bequests) go to the largest, the richest, and the most prominent.

Ellis goes on to argue that, given the continually undercapitalized state of museums which makes it hard for them to maintain buildings and retain staff, this expansion is often resorted to out of weakness. Museums are reliant on generally shrinking subsidies from the state, and sponsorship or other arrangements with patrons and business. The most popular ways to recapitalize are putting on blockbuster shows and going for expansion. It is far easier to get private funding for glamorous expansion projects than for subsidizing the regular running of a museum. The difficulty with expansion is that in the long term, unless the programme has been so successful that it has generated further funding opportunities, it exacerbates the underlying problem, leaving the museum with larger buildings to light, heat, staff, and maintain.

An effect of this extraordinary expansion is, plainly, to stimulate the production of art. As Howard Becker points out, we never come across empty galleries for lack of sufficiently good art to display, so both the standards of judgement and the quantity of output must be elastic enough to fill them. This has doubtless been another stimulus in widening the global reach of contemporary art, since artists can always make more of it.

In this increasingly competitive environment, museums have branded themselves. A pioneering example here is the

Guggenheim operation, a global museum franchise, and its most evident manifestation is the Guggenheim Bilbao. Under the directorship of Thomas Krens, the Guggenheim expanded, with new spaces in Berlin in alliance with Deutsche Bank and two further branches that were to become casualties of the recession in 1999–2000. The most daring venture was in Bilbao, a once wealthy industrial city far from the tourist trail, divided by separatist politics, including ETA bombings and assassinations. In Kim Bradley's detailed account, the museum was tied to the development of the city's port, new subway, and airport, and above all to retail, office, and residential developments. It has certainly been an extraordinary success in turning Bilbao into a tourist destination, branding the city with Frank Gehry's bravura sculptural building, clad in titanium. The regional government paid a heavy price, covering all of the Guggenheim's costs to conceive, design, build, and run the space. A US$50 million acquisition fund was established, though the works purchased would remain property of the Guggenheim. On top of this, there was a US$20 million tax-free payment for loan access to the rest of the Guggenheim collection and for the use of the brand name. The museum has been marketed mostly at foreign tourists, and the extent to which it would engage with Basque interests was hotly debated in its early years. Its purchases and shows, despite another large sum of money granted by the regional government for the development of a Spanish and Basque collection, have been mostly of well-known US and European artists. We have seen that installation art ensures attendance from a committed art audience. Architectural extravagance can do the same, and the two regularly come into symbiosis, as installation responds to its setting. While the region has been transformed—and the museum played a part in this—it did not do so alone, but as part of a concerted programme of development and infrastructure spending.

More broadly, for an arts organization, the Guggenheim is a particularly transparent business enterprise, which bends its

exhibition programme to its financial interests. *The Art of the Motorcycle* was the first of a number of shows that seemed to be more opportunities for sponsors than displays of culture. *Giorgio Armani*, held at the NY Guggenheim in 2000, was a puff piece that, it was suspected, had some relation to Armani's US$15 million sponsorship deal with the museum. The show was a display of currently available merchandise, rather than a historical survey of the fashion house's products, and neither the display nor the catalogue did more than celebrate Armani's designs. Armani had, in effect, hired the museum to display an elaborate advert.

The Guggenheim enterprises point to broader trends. As we have seen, branding in the art world has flourished as galleries, museums, and some artists strive to impress their identities upon the public. Marina Abramovic, for example, has become a brand out of which her art is made, and one of such an open and publicity-seeking kind that, despite the bravery and gravity of her early performance work, her recent moves are greeted with widespread scepticism. Such artists as brands are allegorical figures that, like robots, deliver predictable outputs—behaviour, statements, and objects. At a meeting on arts sponsorship held at the Royal Society for the Arts in 2001, a representative of Selfridges put the matter with candour: the display of Sam Taylor-Wood pictures across the façade of the shop during its refurbishment was a bringing together of the two brands, to the benefit of both.

As art galleries and museums absorbed business practice and searched for larger and more diverse audiences, their character was transformed. Here is Bourdieu in *The Love of Art* on the still unchanged European museum of the late 1960s, imposing on its viewers the idea that what they experience there is utterly different from everyday life:

> the untouchability of objects, the religious silence which imposes itself on visitors, the puritan asceticism of the amenities, always

sparse and rather uncomfortable, the quasi-systematic absence of any information, the grandiose solemnity of décor and decorum.

It is enough to visit Tate Modern to realize how much has changed: architectural drama still serves to impress on the viewer the importance of what they are seeing, but the result is rarely solemn. The galleries, which play second-fiddle to extensive amenities and circulation spaces, are thronged with people, who are happy to raise their voices, information is plentiful and there are some areas, at least, where interaction is encouraged. In the great playground that is the Turbine Hall, even grave and mournful works, such as Salcedo's *Shibboleth*, which opened a crack down the length of the floor to signify segregation and racial hatred, was taken as shallow entertainment, just like the swings and slides that have been set up in the same space.

These changes were part of the opening up of the art enclave to the processes of modern commodity display and financialization. Two of the trends we have looked at in this chapter push in opposite directions: accessibility and more standard forms of commodification towards at least a partial merging with commercial culture; and the much weaker force of the academic professionalization of art towards autonomy and elite discourse. The contradiction is mitigated through the action of the state, because the very purpose of professionalism, at least in the museum, has been effective public communication.

There are areas where state and corporate uses of art come into greater tension. The state seeks to counter the hollowing out of democracy and the decline of sociability caused by unrestrained consumerism—the very result of the corporations' actions. The corporations' main purpose is to sell goods and services to an increasingly cynical public, suspicious of conventional marketing methods. The direction of state policy is towards social inclusion and a broadening of the art audience. The interest of corporations lies in art's very exclusivity and association with elites and

celebrities, a privileged realm that confers upon them the sanction of high culture and access to continued media coverage and profits. The more transparent that relationship becomes, the more art is tainted by it, appearing to be just another part of the general run of mass culture with its wearying apparatus of publicity and celebrity. No doubt the intention of having Madonna announce the Tate's Turner Prize in 2001 was to further raise the profile of the event, while likewise elevating the pop star by association with high culture. The effect, though, was that every viewer knew just where they were, in the familiar domain of PR, and the art displayed took on the role of more or less interesting diversions to the main spectacle of the star's publicity-hungry misbehaviour— by sneaking the word 'motherfuckers' onto live TV.

The branding wars of the 1990s made art a more important element in the management of commercial images. This demotion of art's status can only continue, for corporations that care about their public image or are involved in the 'cultural industries' cannot leave the advantage of participating in the arts to their competitors. Systematically, there is nothing that corporations can do but continue to undermine art's autonomy, the very basis of its attraction.

The fundamental contradiction is that the mainstream of fine art, from its archaic and protected enclave, propagandizes the very forces of unrestrained capitalism that, applied to art, lead to its destruction. Benjamin Buchloh notes that the model of culture to which states subscribe has become corporatized, and that corporations want to reduce aesthetic experience to fashion; this model, he writes, is profoundly at odds with a democratic ideal of culture in which the public defines and comes to see itself. The ghosts of those ideals still cling to the arts and remain central to many people's views of art, no matter how regularly their expectations are left unmet. This is the key to opposing the use of art as a servant of business and the state, and as a plaything for the super-rich, and we will return to it in Chapter 6.

The contradiction is further exacerbated by the modernization of the art market, in faithful reflection of the neoliberal system. As we have seen, the art market has been subject to greater financialization, as art collecting has become merely one investment among many. It participates, too, in the great rise in asset prices, especially following 2008, when trillions of dollars' worth of 'quantitative easing' were passed to the banks, enriching the already wealthy, and the super-rich most of all. It plays a part in the legal, quasi-legal, and illegal evasion of tax, and thus of the neoliberal cancer that rots the state. It is not just built on inequality but produces it, as a very few branded artists, global galleries, art fairs, and auction houses take the major share of the new growth. And it not just produces inequality but dramatizes it, weaving the capitalist fables of exceptional talent and exceptional reward, the dreams of a gilded life, of genius and the zeitgeist, into the fabric of the culture in the extreme form of the branded star artist. And finally, it is built on illusion and debt, on the many thousands of art students, would-be artists, volunteers, and interns—the minimum-wage labourers on which the system rests. The faith that underpins art's cultural value is only as strong—or as fragile—as the belief in those old, seductive fables. In the end, the value of art is a belief system, built not only on ideology but, as with all investments, on a bet about future growth.

Chapter 5
The end of the end of History

It is a basic art-world orthodoxy, echoed just about everywhere, that contemporary art is ungraspably complex and diverse. The variety of contemporary forms, techniques, and subject-matter in art is indeed bewildering. The traditional media of painting, sculpture, and print-making have been overlaid with installation and 'new media', a term which can encompass anything from online art to computer-controlled sound environments. Artists cultivate for themselves images that range from traditional guru or shaman roles to beady-eyed, tongue-in-cheek chancer and careerist, and personas that include starstruck adolescent girls and engorged, axe-wielding psychotics. Art's concerns are also various, touching upon feminism, post-colonialism, identity politics, mass culture, shopping, conflict, memory, and trauma. Works such as Tania Bruguera's feminized Tatlin gliders—which render Russian Constructivism in delicate, gauzy materials—are just one example of the general art-world revulsion at coherence. They bring two sets of opposing terms into a single sculptural form, marrying masculine and feminine, engineering and dress-making, utopian construction and bricolage in a compact that reflects critically on each of the terms. As is usual, no synthesis or resolution is on offer. Perhaps art's fundamental condition is to be unknowable, perhaps concepts embodied in visual form can encompass contradiction, or perhaps those that hold to this view are helping to conceal an underlying uniformity.

There are several reasons to suspect that the conventional views conceal something. First, most art is instantly recognizable to both novices and the informed, and not just because it is on display in a gallery. While there are stories of cleaners throwing out, say, a piece of string that happened to be a valuable piece of conceptual art, they are rare. Second, total randomness (maximum entropy) is one form of total uniformity. Each element of art's variety is hybridized with others in a process that leads to a wider homogeneity. Third (in tension with the second thought), as we have seen, permissiveness is far from total, and much cultural production is rigidly excluded from the contemporary art world. Finally, much current work (like advertising) uses visual signs in a highly conventional manner. So it may be that art's knowability is on the increase, along with statements boasting its essential unknowability.

There can, of course, be no pretence to scientific objectivity in any account of art. No analysis can be objective in the way that, say, the examination of beetles can, since any account has some effect over the very scene that it surveys. The stultifying power of Greenberg's sweeping account of the development of modern art as a Hegelian march towards formal abstraction helped stimulate Pop Art, its explicit refutation.

Since the rise of the avant-garde, only art viewed from a historical distance has appeared to have direction and coherence, while the present always seems clouded in confusion. This loss in the present of the orientation that we appear to have when looking at the past is long-established. In fact, those writers such as Greenberg who, for better or worse, grasped without ambiguity an impetus in the present have been the exceptions. Any historical account of art simplifies what we see, reducing it to what is of interest to the present; but perhaps this is simply the necessary task of intellectual work in which diverse phenomena must be ordered, placed in hierarchies of importance, and much ignored or forgotten, to achieve a meaningful perspective on a scene.

Such work is evident through our own period, as the art of what was once thought of as the global periphery travelled to the centre of art-world attention; as the work of neglected women artists, past and present, was finally brought to prominence in art history and with major museum exhibitions; and as an underground history of gay artists has been assembled into an open and vibrant tradition. For example, veteran figures of the feminist movement—including Chicago, Rosler, Mary Kelly, Sanja Ivekovic, and Ana Mendieta—have been the subject of major retrospectives, revivifying their work for younger generations of activists, and bringing them into artistic dialogue. In a similar effect, black artists of the 1980s have found their work brought to new prominence—in the UK, we may think of exhibitions by John Akomfrah, Sonia Boyce, Frank Bowling, and Lubaina Himid. These are radical acts of restitution, in which the present reorders the conservative histories of the past. Such reordering is, however, a typically art-world form of redress: not the reform of the overall field—which, despite these gains, remains steeply biased against women, for example—but the elevation of a few exceptional individuals to Olympian heights. Its registering of class prejudice, in strict conformance to the neoliberal view, has until recently been too faint to be detected.

Art in the 1990s and beyond was sometimes thought of as a synthesis between grandiose and spectacular 1980s neo-expressionism with the techniques and some of the concerns of conceptual art. The result was to splice linguistic and conceptual play with visually impressive objects. Tobias Rehberger's *Seven Ends of the World* (2003; Figure 19), to take a single example, fills a room with clusters of glass balloons that glow with different coloured lights in a beautiful, slowly changing display; the lights in the balloons are renditions of local light conditions in various places around the world, relayed over the Internet. The piece is both a technically accomplished, spectacular, and appealing object, and the manifestation of an idea.

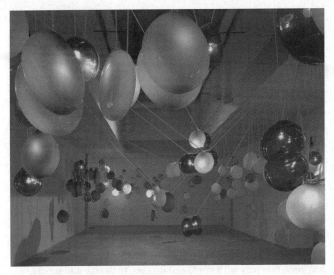

19. Tobias Rehberger, *Seven Ends of the World*, 2003.

Perhaps this synthesis is the result of a negative dialectic, which has forced on art not a realization but rather a taming of conceptualism's radical critique, in a false accommodation with what it most despised. Veteran conceptual artists Art and Language hinted as much in an installation shown at the Lisson Gallery in 2002. Here they remade their famous *Index* work— originally a card-index piece meant to encourage interaction and dialogue—as a candy-coloured functionless sculpture, juxtaposed in reference to the antics of the young British artists with a nonsensical pornographic text.

A spectrum of art is composed of the varying elements of this synthesis. One end—the most conventional and the most likely to be associated with unreconstructed notions of male genius—mixes the barest elements of a conceptual framework with large quantities of what we are meant to take as emotion, spirituality,

and the universal to warrant the production of epic work. We might think here of Bill Viola, Anish Kapoor, Antony Gormley, and Matthew Barney. At the other end, concepts take the lead, driving the production of objects in materials or media that are selected to suit them. Both ends react against the pervasiveness of the mass media: the first presents the viewer with a sublime or imposing spectacle featuring massive amounts of material or data; or in performance, the body and sometimes blood of the artist form an assurance of organic and unique presence, as against all that is copied and transmitted. At the other end, mundane elements of the environment or the media are pitched into non-instrumental play: this can be seen clearly in works that take mass-media spectacle and simply remove the spectacle, one example being Paul Pfeiffer's digital alteration of the film of the Ali–Foreman boxing match, 'Rumble in the Jungle', to delete the boxers. Indeed, a defining feature of art since the end of Cold War has been this play with borrowed images, material, and media, which has whittled away at the deep, serious art of manifest genius until its practitioners, now few, appear as eccentric survivals of a previous age, while traditionalists can only wail at the blanket dominance of 'conceptualism' and 'installation'.

So readymade objects (or at least readily recognized objects) and signs are moved from one place to another, and assembled in novel reconfigurations. Think of artists' treatment of that most valued of consumer objects, the car: there is Orozco's famous *La DS* (1993; Figure 20), a Citroën DS cut lengthways, a portion taken out of the middle, then stuck back together to make a slimmed-down version; or Gabinete Ordo Amoris' elongated Lada taxi (three have been welded into one) to make a Cuban taxi-limousine, commenting prettily on the peculiarities of the rise of the nouveaux riches on the island; or Damián Ortega's exploded Volkswagen, its component parts hanging like a three-dimensional diagram of a kit-assembly of the car on wires. (There are plenty of other examples, from Rehberger, Fleury, Charles Ray, and others.) These movable elements may be qualities as well as

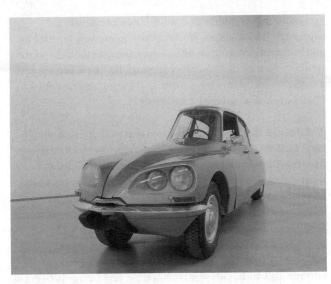

20. Gabriel Orozco, *La DS*, 1993.

things, as with Paola Pivi's inverted jet fighter, Akiko and Masako Takada's miniature Turkish carpets, Orozco's pocketless *Oval Billiard Table* (1996), or Maurizio Cattelan's *Stadium* (1991), an elongated table football game that can be played by twenty-two people at once.

This is equally true of 'traditional' media, including painting, in which the assembly of readymade elements takes a different form. One of the most successful painters in commercial terms is Christopher Wool who stencils letters onto the canvas to spell out slogans or odd descriptions, such as 'CATS IN BAG BAGS IN RIVER'. Marked out as art by the omission of spaces which means that the words must be deciphered rather than quickly scanned, they refer to street slogans and, as Peter Schjeldahl puts it, merge 'the anonymous aggression of graffiti with the stateliness of formal abstract painting'. Occupying a niche that mashes up references to

various strands of mid-20th-century US painting, with a supposedly dark nihilism, Wool provides an immediate visual hit, and sufficient gesturing towards deeper meaning for those who trouble with such matters. In recent years, they have become such a target for speculative investment, that one curator described Wool's work as 'a parking lot for money'.

A vast range of art has been produced that contains such simple combinations of elements. To survey a large number of these is to have the (illusory) impression of an art-world machine that wrenches elements out of their functional place in the world and recycles and recombines them, so that, taken as a whole, any combination of signs and objects will eventually be arrived at. Displacement is a key technique of advertising, which, like art, must shock and amuse or at least intrigue the viewer; use and placement are the main elements that separate art and advertising, which otherwise remain close, and engage in frequent theft from one another.

If it seems as though artists will mix and match anything, like toddlers rearranging all objects that come to hand, this play is not incidental bad behaviour but something structural. As Howard Singerman puts it: 'The [art] student's task, like that of his works, is to take—and to mark—his or her place'—one which is distinct from all the others trying to do the same. As more and more positions are filled, it seems as if no bringing together of elements is taboo. An extreme case is Zbigniev Libera's *Lego* (1996; Figure 21), a series of concentration camps built with the children's building blocks, which along with other similarly provocative works about the Holocaust were displayed at the Jewish Museum in New York in a show called *Mirroring Evil* in 2002.

Seen from the point of view of each artist's individual projects, such pieces are various, distinct, and personal. Seen from the point of view of the art world as a system, they appear as the component parts of a uniform machine, which produces a vast

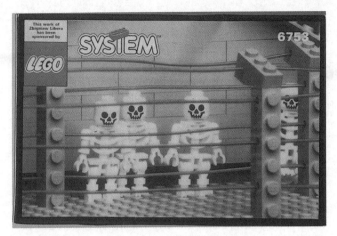

21. Zbigniew Libera, *LEGO Concentration Camp*, 1996.

range of novel combinations that are tested against various publics for marketable meaning.

Lest Hume's point—that all human imagination is nothing more than the combination of found elements—be thought to apply here, it should be said that, in comparison with modern and even many postmodern practices, these combinations have become simpler, their elements more manifestly found, their recombination more promiscuous and arbitrary, and the meanings that they generate more fleeting and cursory. There is a relation between the rapid play of images and the development of free trade, which erodes cultural barriers, historical memory, and identities in favour of the fungibility and mobility of objects, signs, and bodies. As economic growth is essential to capitalism, and the material constraints of population, environment, physiology, and indeed physics constrict it, the circulation and consumption of immaterial goods speeds up.

The rise of street art is one prominent symptom of this association between speed and simplicity. Once held in a relation of mutual

disdain with the art world, from the mid-2000s it rapidly made its strange ascension to commercial success at gallery and auction. It has been particularly attractive to new collectors, many of them celebrities such as David and Victoria Beckham or Pharrell Williams, as they bought into the fervid fame of the new stars. Social media transformed street art: while it had once spoken fleetingly to those in its immediate locale, and was soon erased or overwritten, now it could be fixed photographically and shared globally. Much of it became driven by the quest for praise and fame. Banksy is only the most obvious case here, combining anonymity and a branded signature style to achieve celebrity and with it great market value. That value, proved at auction and in numerous gallery sales, is in one sense a puzzle since, on the old forms of judgement, Banksy's work is not art-like (Figure 22). Its messages are very simple, clichéd, and instantaneously grasped, relying on highly familiar advertising techniques; his signature style is likewise little troubled by complexity; and as with most street art, popularity, speed of production, and ubiquity are prized above much else. Yet it hangs in prestigious collections alongside

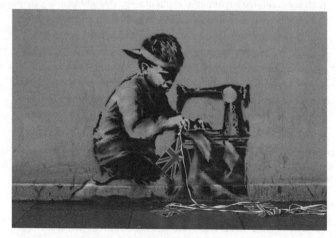

22. Banksy, *Slave Labour*, mural, 2012.

the great and more conventionally good. The same may be said of many others, including George Condo, JR, Shepard Fairey, and KAWS. That Banksy is both critical of and prepared to exploit his art-world fame and value is shown by the stunt in which he auctioned a print of one of his best-known images, *Girl with Balloon*, with a shredder built into the frame: as the hammer fell, the work partially destroyed itself.

The success of street art is remarkable and it points to a deep shift in the constitution of the contemporary art world. Varieties of accessible figure painting of the kind collected by Saatchi, among many others, which would not look out of place on a city wall, populate the art fairs. The contrast can be seen in the fact that cultivated collectors of the 1970s did not hang Roger Dean paintings alongside their Picassos, or the works of Vladimir Tretchikoff or Michael Whelan for that matter.

The shift is partly caused by the increasing use of art as pure investment. If you buy a work simply to lock it in a free port vault and sell it on later, you do not need to see it, let alone live with it. But since some collectors do, displaying such works with pride, a deeper transformation is at work as the effect of social media takes hold—that the role of the marshallers of culture increasingly moves from commanding what will be popular to merely framing it. And this marks a further erosion of bourgeois values, which once bound up the beautiful, the good, and the true in the singular package of art, and later favoured the modern and the future-oriented in works of rigour and complexity. Now, what is popular is valuable, and what is valuable is popular.

In an earlier moment, this endless blending of signs and objects had found its hagiographer in Arthur Danto, who for many years wrote for the left-liberal magazine *The Nation* and was a very well-known philosopher and theorist of contemporary art. His influential book, *After the End of Art*, claims that the character of art has changed radically since the 1970s, which saw the last gasp of

the avant-garde, and that it is now properly post-historical. Modernist and avant-garde views were tied to narratives of historical progress—towards formal abstraction, perhaps, or the merging of art and life. For Danto, in contrast, 'life really begins when the story comes to an end', and those who now expect art to progress have missed the point, which is that the final synthesis has been reached. While Danto does not mention him, this stance is close to that of Francis Fukuyama's political views in his widely publicized book *The End of History and the Last Man*, and is based on the same Hegelian contention that, while of course events continue to occur, History has come to a close so that we are settled for ever with a version of the system which now sustains us. Written while Fukuyama was employed at the US State Department, and beautifully timed to reflect upon the fall of Eastern European communism, the book was issued to great acclaim in 1992. The two views ran in parallel, for if the great political narratives had come to an end, so had any prospect for the radical transformation of society and culture. Indeed, Fukuyama explicitly says that this era marked the end of all socially useful art. Similarly, for Danto, once art had passed through the black night of the 1970s (which, with its dreadful, politically engaged work, he compares to the Dark Ages), it emerged onto the sunny Elysian Fields of universal permissiveness, never to leave. And in those fields, any mixing of styles or patching together of narratives is as good in principle as any other.

Just as Fukuyama's book echoed with the times, so Danto's offered a plausible description of contemporary art in the 1990s. It had considerable resonance in the art world, and figures who are much at odds with Danto in other respects echo it. For instance in his book *Design and Crime* Hal Foster, one of the most influential and sophisticated academic writers about contemporary art, describes art's current 'symbolic weightlessness' and its disengagement from history: 'One might go further: contemporary art no longer seems "contemporary", in the sense that it no longer has a privileged

purchase on the present, or even "symptomatic", at least no more so than many other cultural phenomena.'

Danto wants to say that contemporary art is 'contemporary' but that means more than merely art made now: 'the contemporary is, from one perspective, a period of information disorder, a condition of perfect aesthetic entropy. But it is equally a period of quite perfect freedom.' That freedom was produced by the view of art that asked philosophical questions about its conditions of existence, and was no longer tied to questions of how it looked. Liberated from the burden of that history, artists could make work 'in whatever way they wished, for any purposes they wished, or for no purposes at all'. This is a fully utopian achievement, which Danto has little hesitation in comparing to Marx and Engels' vision of communism, in which people freely fulfil themselves in the activities of their choosing.

Declaring that the present is the end of History did not go any better for Fukuyama than it had done for Hegel. As Fukuyama later admitted, rapid technological change led to unforeseen social and environmental disruptions. The events of 9/11 and the meting out of exemplary violence in the so-called 'war on terror'—which included the flouting of laws against state kidnapping, torture, and murder—formed one obvious break point, since those crimes threatened the legal foundations of the liberal order. The economic crisis was another, and the imminent threat of ecological collapse yet another.

More recent views of the contemporary are unsurprisingly less comforting than those found in Danto. Sometimes they point to a similar sense of being becalmed, but no longer happily. Using Osip Mandelstam's poem on the turning of the year 1900, Giorgio Agamben's typically involuted and lyrical meditation points to a view of the contemporary as radically and painfully out of kilter with its time. For Agamben, those who dwell complacently in the present are dazzled by the light of their time. The contemporary

mind, by contrast, is attuned to its darkness, and while Agamben's metaphor is astronomical (galaxies that are receding from us so fast that their light will never reach us), given his invocation of St Paul and Walter Benjamin, it is also surely redemptive. The lack of ease with the present runs through other accounts: for James Meyer, the scene is summarized by Glenn Ligon's disillusion with the black political resistance of the past which now seems merely quaint, and by an unstable and amnesiac relation to the past, since 'the current moment keeps hurtling forward and the historical past likewise refuses to sit still for very long'. Peter Osborne, in a complex philosophical analysis of contemporary art, favours works of radical negation which continually disrupt our sense of time, and especially any expectations for the future. For Terry Smith, contemporary art poses a number of irreconcilable views of the contemporary condition, split between a bland acceptance of what happens, an elitist recommendation of quality as inhering in the museums and the market, and (especially from post-colonial nations) the co-existence of many incommensurable views and time frames. Indeed for Smith the fact that these perspectives can never be either reconciled or fully separated is the essence of the contemporary—we live in a time of inescapable friction, in part caused by growing inequality.

All of these views, then, point to a deep unease in which time is out of joint. They reflect the character of an art world that has become increasingly split. Competing with the spectacular, expensive art objects, destined for the museum wall and the billionaire's mansion, much art engages in arresting and unprecedented forms with the global reach of exploitation, deep histories of oppression, the prevalence of gender inequality and racism, geopolitics and the 'war on terror'. A further fragment seeks to engage various publics in participation, dialogue, and even social change. Each has its core institutions—respectively, the art fair, the biennial, and the residency, commission, or art festival.

Social engagement by artists in the 1990s had taken a pallid and palliative form, which was nevertheless the basis for more radical developments. For Nicolas Bourriaud, in his influential book *Relational Aesthetics*, 1990s art was most characterized by work that made social interaction an aesthetic arena, offering services or contracts to visitors or simply easing contact between them. One of his examples illustrates the idea well: Jens Haaning broadcast jokes in Turkish through a speaker in a Copenhagen square, forging a temporary bond between those who understood and laughed.

Bourriaud is a curator and was a co-director of the state-run contemporary art space at the Palais de Tokyo in Paris, so his views were formed by working with and talking to artists. His book is not merely a discussion but a promotion of the art that he recommended by figures such as Vanessa Beecroft, Liam Gillick, Philippe Parreno, and Rirkrit Tiravanija. For Bourriaud, art that encourages interaction among its viewers reacts directly against a general trend towards increasing social fragmentation, from ever greater specialization at work to the tendency for people to lock themselves away in their homes in the company of media rather than other people. This condition can be eased through art: 'Through little services rendered, artists fill in the cracks in the social bond.' Such a humane and democratic art offers not theoretical prescriptions but small, momentary, and subjective 'hands-on utopias' in which people can learn to live better. Yet this 'arena of exchange' must be judged aesthetically, through an analysis of its form. Social relations are treated as another artistic medium to add to photography, video, and installation. These works may well include things that look like conventional art objects and which may be bought and sold, though they too should be judged ultimately for the aesthetic power of their social interventions. For example, Tiravanija became well known for staging dinners offering free curries in various art spaces. Diners would become part of the art as they conversed and ate. As Noah Horowitz recounts in his book, *Art of the Deal*, one gallerist paid

Tiravanija thousands of dollars to stage a dinner in his home, and the artist regularly sells various relics of the events from menus to tins.

If such work is self-consciously token and futile, standing Canute-like before the tide of social division and alienation, then the rise of this art may be less positive than Bourriaud thinks. Coupled with thinking about the hollowing out of democratic politics (remember the Swedish 'average citizen'), what Bourriaud describes is merely another art-world assimilation of the dead or the junked, the representation as aesthetics of what was once social interaction, political discourse, and even ordinary human relations.

This type of art was, however, congenial both to business and governments (particularly those of a social-democratic inflection, hence its prevalence in Europe during the 1990s). Governments, as we have seen, looked to art as a social salve, and hoped that socially interactive art would bandage the grave wounds continually prised open by capital. Corporations also employed it to leaven workplace environments with creative play, and free up company structures and methods with innovative thinking. Art was refashioned as management consultancy. Ultimately, this art's purpose was to assure its educated viewers that, despite the corruptions of democracy, the manipulations of the media, the pollution of the mental environment by endless and strident commercial propaganda, they can still be themselves, undamaged and free. When artists sanction it, they can even engage in meaningful social discourse with like-minded strangers.

A break in this cosy thinking came when Claire Bishop launched an attack on relational aesthetics, on the perfectly reasonable grounds that the society in which such art intervened was hardly harmonious. Drawing on Chantal Mouffe's theories of political antagonism, Bishop recommended work that dramatized and visualized social conflict, rather than sought to relieve it

temporarily: among her examples, Tania Bruguera and Santiago Sierra. Bishop's foray was met with furious denunciations by Bourriaud's allies—a sure way to know that a nerve has been hit.

There is a long history of antagonistic art (traced in Bishop's book, *Artificial Hells*), from Dada performance, designed to trample on bourgeois sensibilities, to Ant Farm's 1975 fiery collision of the two icons of US life, TV and the automobile. In recent art, and especially since the financial crisis and the Occupy movements, as we shall see, such practices have been adopted with increasing gusto.

In the new century, in a marked development, much art that sought to be socially useful in more than an aestheticized and token sense started to appear in major art venues. Suzanne Lacy, for example, has been making such work since the 1970s, but has recently received much attention from museums and biennials, and has revised early actions and performances for new sites. At Tate Modern in 2013, she reworked her events that had dealt with the invisibility and frequent impoverishment of older women. In *Silver Action*, 400 women over 60 years of age, all veteran activists, gathered to discuss their involvement in the women's movement, and the changes that ageing can bring to political opinions. The artist saw herself as the facilitator of this participatory project, in which workshops led to a six-hour event during which the women's discussions, managed by Lacy across different spaces, were shown as video projections.

In the early 2000s, the years of the art investment boom were also those of the unfolding 'war on terror'. While the excesses of the boom mocked the political principles of cultural globalization, the war on terror—summed up in President Bush's position that you are either for us or against us—was a more direct assault. On both sides, this was a way of dividing the world between terrorist and hero, religious fanatic and true believer, those who love death and those who love life. The invasions, kidnappings, beheadings,

murders, torture, extra-legal imprisonment, and the bombing of civilians (whether with home-made explosives or million-dollar missiles), much of it captured on photography and video for propaganda purposes, were the products of that division as it fractured the globalized ideal.

Both sides were transformed by their fundamentalisms. The US and its allies snatched people from the streets to be interned indefinitely in secret torture centres. They imprisoned children to extort information from their parents, or launched missiles into places where some algorithm judged that a person had a pattern of action that matched terrorist behaviour, killing or maiming all in the vicinity. Across Europe, a few home-grown Islamist terrorists staged their own brutalities, producing—as intended—further state surveillance and repression.

One direct response in the art world was a marked revival of a great variety of documentary forms. Generally dismissed in the postmodern era as a naïve and overly political form, it has become a staple of the biennial scene. Technologically, it has become much easier and cheaper to make high-quality photography and video, and the media landscape has been changed beyond recognition by mass participation through social media. Often sophisticated, self-referential, performative, and even partially fictional, this revived documentary—by artists such as John Akomfrah, Ursula Biemann, Harun Farocki, and Hito Steyerl—matches radical politics, form and technique. Sometimes seen in black box spaces, sometimes in complex multi-screen installation which allow viewers to effectively make their own edits through the choice of where and when to watch, this work dealt with the major political and social issues of this remade, perilous and precarious world.

To take a single example, Rabih Mroué's 2012 installation and video, *The Pixelated Revolution*, looks at the relation of cameras and guns in the Syrian uprising. Why, Mroué asks in his compelling video-lecture, do people risk their lives to make photos

and videos, even to the point of continuing to film while being shot at? He shows a few instances when it is clear that the person behind the camera sees the gunman turn towards them, raise his weapon, and take deliberate aim. Still they keep filming as the gun is fired. Mroué makes the point that the videos are also weapons, when distributed in Syria and beyond, and are essential to feeding the resistance; also that the phone camera is not used like film cameras of old but becomes a prosthesis, an extension of the eye which is continually active, even when the images produced, for instance in scanning the urban landscape for danger, are to the outside viewer a jumble of meaningless frames, piled jerkily one on another.

As the boom and the war on terror coincided, the biennial, a thermometer of art world climates, registered both, crazily. So the phenomenon of the split biennial emerged, in which the formal and the political were pushed up against each other without sufficient reflection or mediation: signal examples here include Robert Storr's Venice Biennale, and Roger Buergel and Ruth Noack's Documenta XII (both 2007). The bewildered viewer, unenlightened by confused curatorial justifications, moved from decorative abstraction and knowing kitsch to large-scale displays of documentary photographic and video work that referred to the most hideous and desperate human situations. This was the high-art reflection of the fracturing of globalization—in broken and deeply split biennial displays, which no longer seemed to function placidly as the mere emanation of the aesthetic tastes and ideals of the curators, but also registered, with acute discomfort, the political storm beyond their walls. Occasionally, as in the work of Richard Mosse or Edward Burtynsky, spectacle and political disaster collided in very large, high-resolution photographs of civil war and environmental despoliation. In the worst cases, as Oliver Marchat points out, the political, and even terror itself, was rendered aesthetic. Yet this schizophrenic splitting was to be the herald of further and deeper rifts to come, which were to open more radical possibilities.

Chapter 6
Fracture

Since the 2008 crash, the art-world split has widened: what were cracks have become fissures, and what were tensions, open conflict. If contemporary art was always a flag of convenience under which sailed a range of diverse practices—from transient performance activism to the making of monuments to self-glorification—its deeper coherence is now called into question.

In ideology, Marx and Engels claimed, things appear upside-down. Much contemporary art celebrates as the exercise of freedom all that is forced on us. It does so plausibly because a freedom allied to consumption is the experience of the elite who view art—the adopting and discarding of roles, and the multiple identities constructed through consumer choice. Recent events point to a systemic crisis: the long-lasting recession which has for over a decade weakened many nations; the dire fallout from the US imperial project as manifested in failed states, apparently endless civil wars and massive migration; increasingly catastrophic environmental events, harbingers of worse to come; and lately a pandemic—probably caused by human encroachment on wilderness—which threatens the deepest global recession in living memory. In all this, stranded and frail neoliberal governments promise—but cannot deliver—merely a return to the feeble growth rates and rampant inequality of the pre-crash era. Their hold on the reins of power loosens.

In contemporary art, a profound rift has opened up between the marketized art directed at the super-rich, extravagantly expensive, and often familiarly standardized, in which the mismatch between buzzy PR and dull product is plainly evident; and a world of artistic social activism, which has evolved from its merely performative and gestural acts against an overwhelmingly powerful system. Now sensing both the system's weakness and impending disaster, it has become both urgent and insurgent.

The culture of the super-rich is seen most clearly at the art fair. The restless, global, event-driven art world has become ever more environmentally damaging. Against a backdrop of digital flows, social distinction is manufactured by couriering heavy lumps of matter from continent to continent. Collectors, artists, dealers, and curators follow them about; they are the aristocracy of business class and the private jet, burning up the ecosphere for the luxury of a reclining seat or a few inches of extra legroom. Hans Ulrich Obrist, the doyen of globe-trotting curators, claims to have made 2,000 trips in the last twenty years.

Some of the plumes of exhaust and smoke that humanity emits warm the shivering, feed the hungry, and make things that sustain body and mind. But what is seen in the art fair takes the Kantian command to be useless and makes of it the sign of conspicuous consumption: look at my money! The more art is useful (for investment, tax evasion, money-laundering, and entry to the elite) the more it parades its principled uselessness. The fairs are the result of steadily growing inequality that has fed the art market, while driving down the incomes of ever-larger portions of the population.

The richer you are, the general rule goes, the dirtier. As the artist Andrea Fraser argues in a notorious essay, the 0.1 per cent that buys art is disproportionately composed of crooks, swindlers, tax-evaders, and the architects of banking scandals. Old money rests on the foundations built by slavery, drug-dealing, and myriad

exploitations of the environment and people. The new, very often, on corrupt privatizations, sweated labour, environmental despoliation, and collusion with the military-industrial-surveillance complex. The richer you are, also the noisier, as an incessant chorus is heard across the media chanting about their work ethics, the depths of their creativity, their many virtues (including, of course, their 'patronage' of the arts), and insisting above all that everyone needs them: that without them would lie the end of wealth, the end of innovation, the end of the individual, and the end of art.

Despite all this noise, it is a curiosity that so many people purchase expensive tickets to visit these art malls, at which the vast majority of the products are priced far beyond their reach. Given the tensions of the current situation, these visitors may find it harder to put out of their minds the oppression and impoverishment on which the glitzy spectacle insouciantly rests. As we have seen, increasingly uniform and thus market-assured products lead to an air of tawdry familiarity and even boredom. Given the environmental catastrophe against which they are set, future generations may look on our various spectacles of conspicuous consumption—the art fair, and the fashion, yacht, or car show, with the same incomprehension and horror that we look on the mass slaughter of the buffalo, or the collecting of thousands of song birds, stuffed and displayed in glass cases, or the use of monkeys' paws as ashtrays. It is unsurprising that art fairs have occasionally been the site of protest, as when a die-in was staged at the New York Armory Show in 2015.

One response was found in increasingly activist art practices that pushed aside the long-established neoliberal edict that art and overt political action could not co-exist. One arena, even in the 1990s and early 2000s, was online art, for the simple reason that market pressures did not operate there in so intense a fashion. From the mid-1990s, with the rise of the web browser, the dematerialization of the art work—especially its weightless

distribution over digital networks—threatened the protected system of the arts. What is the market to make of a work that is reproducible with perfect accuracy, that can simultaneously exist on thousands of servers and millions of computers, and that can be cannibalized or modified by users? How can one buy, sell, or own such a portion of data? This is a situation, central to Marxist theory, in which modernization of the means of production comes into conflict with the relations of production. In digital art, the use of new technological means to make and distribute work came into conflict with the craft-based practice, patronage, and elitism of the art world.

Artists made interventions in online space, as corporations pushed to change the Internet from forum to shopping mall. That commercial colonization was a rich subject for Internet artists, who produced many sharp and sophisticated pieces designed to draw the shopper up short. One of the most notorious was staged by the art corporation, etoy (Figure 23). Their *Digital Hijack* diverted surfers who had typed in keywords such as 'Madonna', 'Porsche', and 'Penthouse' into a search engine, and clicked on etoy's top-rated site, greeting them with the response: 'Don't fucking move. This is a digital hijack', followed by the loading of an audio file about the plight of imprisoned hacker Kevin Mitnick, and the hijacking of the Internet by Netscape. Others—including Rachel Baker, with her prescient examination of customer surveys, data mining, and loyalty cards—have come into dispute with corporations using the copyright laws to suppress freedom of speech. Baker made a site promising Web users who registered for a Tesco loyalty card points as they surf, provided they filled in a registration form that asked questions such as 'Do you often give your personal data to marketers?' and 'How much is your personal data worth to marketing agents?' She rapidly received a letter from Tesco threatening an injunction and damage claims.

This form of art is indicative of an extraordinary development: out of a renewed and virulent species of capitalism—at the point of its

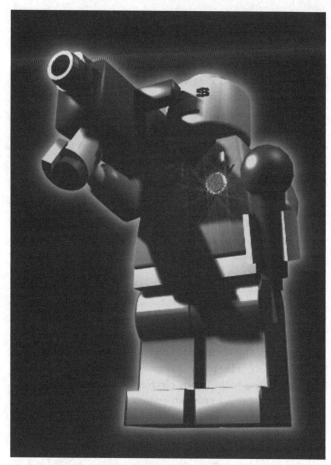

23. etoy, CORPORATION, TOYWAR site, 1994.

apparent triumph—there condensed from fragmented single-issue politics, a coherent movement of opposition. Michael Hardt and Antonio Negri argue that this is no accident, for cooperative values emerge from the very change of the primary economies towards data processing, in which cooperation between users and

producers can be a more important organizing force than investment capital. The result is 'the potential for a kind of spontaneous and elementary communism'. The free software movement—based on just this global, voluntary cooperation protected by a hacked form of copyright law—provides a striking example of such collective work in action.

The synthesis of productive and reproductive technologies in the digital realm raised two corpses long thought to have been definitively buried: the avant-garde and the political use of art. At first online, where the boundaries between production and reproduction are faint, artists rediscovered use-value. Activist works allied to the new political movements—such as *Floodnet*, designed by Brett Stalbaum—have engaged in the direct disruption of consumerism. A campaign against the giant online corporation, eToys—which had used legal action to close down the etoy site—was so effective that, aided by the recession, it forced the company into receivership.

While in the years since early Internet art, the forces of privatization, monopolization, surveillance, and social manipulation have run rampant, as social media and search companies have become global giants, the consequences have often been paradoxical. Following commercial imperatives to keep eyes on the screen, users have been pushed to ever more extreme material with destabilizing political consequences. The constant availability of a vast range of cultural material, of many styles, eras, media, and political inflection has had profound consequences. It can lead equally to trickster performances on Instagram, as with Amalia Ulman (Figure 24) who apparently reinvented herself as a surgically beautified, luxury goods' obsessed airhead before revealing the stream of photographs as a year-long hoax; and to James Bridle's *Dronestagram*, an online mapping of drone strike locations as a way of lifting the veil on the secrecy of the continual programme of assassination, and to bring Instagram viewers a little closer to those places and by extension their inhabitants; and

135

24. Amalia Ulman, *Excellences & Perfections* (*Instagram Update, 24 August 2014*).

to the collective ActiveStills which makes photographic work about Palestinian human rights' issues, and provides downloadable exhibitions to be printed out to make physical displays.

While the great global biennials often oscillate in their visions, as one curator tries to mark out a distinct intervention against the last, these events have increasingly been used to make explicit attacks on neoliberalism and even capitalism itself. Documenta X in 1996, curated by Catherine David, courageously took on the apolitical character of the art world at the height of the 1990s boom, and as a result was roundly condemned in many quarters for being backward-looking and nostalgic. Five years later,

Documenta XI, curated by Okwui Enwezor, was another clear sign that the art of the global periphery had moved centre-stage, and contained an impressive array of critical work, buttressed by discussions taking place at many venues around the world, and the publication of dialogues on democracy, truth and reconciliation, creolization and the African city.

Among the works shown there was Allan Sekula's remarkable self-reflexive and critical project, *Fish Story*, a long sequence of photographs and texts about maritime trade, which for many had been tucked out of sight, mind, and representation since containerization. In 1999, he made a smaller intervention of a few dozen pictures that has appeared in galleries as a slide sequence (it was shown tellingly in the fascist Columbus Monument in Lisbon, and was also seen at the Taipei Biennial in 2008–9), and also follows the texts in a book called *Five Days that Shook the World*. The 'Five Days' are the anti-World Trade Organization demonstrations that took place in Seattle. The texts that frame these pictures—by Alexander Cockburn and Jeffrey St Clair—describe the aims, the tactics, and the factions among the protestors, and the brutal (indeed, potentially lethal) response of the police. Sekula himself, unusually, does not support his pictures with much text, arguing that in the face of such strangeness a 'simple descriptive physiognomy was warranted'. Further:

> I hoped to describe the attitudes of people waiting, unarmed,
> sometimes deliberately naked in the winter chill, for the gas and the
> rubber bullets and the concussion grenades. There were moments
> of civic solemnity, of urban anxiety, and of carnival.

So in waiting, frozen moments are sealed in the photographic frame, but a wealth of time is contained in them, forward-looking most certainly in expectation and dread; backwards, too, for at that time there seemed something archaic about both the demonstrations and these images, a feeling of history reasserting itself (Figure 25). What had reactivated time in such pictures? It

25. Image from Allan Sekula, *Waiting for Tear Gas [white globe to black]*, 1999–2000.

was not the events of Seattle alone but the way they seemed built into a wider movement for change, as formerly fractious single-issue groups coalesced into a broad critique of the way things are.

One origin point for such protests, and for the decolonial movement as a whole, was the Zapatista uprisings in Chiapas in 1994, in which indigenous people—protesting the NAFTA under which 'free trade' was favoured over their right to eat—seized and occupied territory. They continue to hold and expand this territory, which they govern under a system of participatory democracy. As Walter Mignolo argues, this action was the product of a long and transformative exchange of thought between indigenous people and once-Marxist activists who had spent decades in the Lacandon jungle. In 1996, the Zapatistas held the 'Intercontinental Encounter for Humanity and Against Neoliberalism', a remarkable conference, attended by thousands of activists which helped seed the anti-capitalism movement. Colonial history, of which the Zapatistas are acutely aware, was

seen as absolutely central to the development of capitalism, with legacies that structure the present. Objections to it must be ethical as well as economic. While the Zapatistas need no reminder of how unequally neoliberalism distributes its riches and its bullets on racial, ethnic, and cultural grounds, they oppose divisive forms of identity politics that weaken resistance to capitalism, and are in themselves a marker of US cultural hegemony. Their culture, in words, murals, and political performance is an extraordinary meeting of Amerindian and Marxist elements, which defies easy or settled definition.

In the art world, the pulse of insurgent display has grown stronger. Istanbul saw an openly Brechtian biennial in 2008, curated by the collective What, How and for Whom, who showed a wide range of artistic reflections on Marxism, political action, and documentary. The Berlin Biennale of 2012, curated by Artur Žmijewski and Joanna Warsza, invited Occupy to inhabit the largest spaces at the main venue, and to collaborate to create actions, which included an invasion of the Pergamon Museum to protest the colonial seizure of cultural artefacts. Once again, the results were widely reviled by conservative critics on aesthetic grounds, and with reason, since the explicit aim was to lift what Žmijewski called 'artistic immunity' from questions of social use, and indeed not to be content to ask questions but to find answers, especially in solving 'the economic problems of the impoverished majority'. The 2015 Venice Biennale, curated by Okwui Enwezor, was a prominent example of an explicitly engaged event, at which Marxism was very evident, both theoretically and in artistic terms: Alexander Kluge and Isaac Julien addressed Marx directly through their work, the latter through a dialogue on video with renowned theorist David Harvey. *Capital* was read each day in the central auditorium of the main Pavilion, and Marx was listed as an artist in the catalogue!

The common critique of such events used to be based on the very slight likelihood that the art world alone could do anything to

improve matters. If the work is shown without any prospect that it will have an effect, its display becomes mere performance and its viewing a form of entertainment. Yet the very extremity of the current situation, along with the huge growth in the global popularity of art, works against that effect. First, the increasing insecurity of the art-going middle class may slowly pull them into the orbit of the precarious masses. Second, under the pressure of social media, many art works have become easier to understand and more widely circulated: the funny, entertaining, and radical political work of Hito Steyerl, for example, has play well beyond its gallery outings. Last, curators have responded to these changes, making shows and commissioning art that moves from the merely lamentory to the actively insurgent.

The 2017 Documenta, entitled 'Learning from Athens', made just that move. It split the event equally between Kassel and Athens, in an act of restitution which pointed to the EU's imposition of drastic austerity measures in Greece following the financial crisis, in which Germany had taken the hardest line. It too had a very rough time at the hands of critics. Liberals, unsurprisingly, moaned that the dead weight of politics has crushed the delicate flower of aesthetics in an alienating and oppressive series of displays. Despite its steadfast anti-colonial and anti-neoliberal stance, some on the left (including Yanis Varoufakis) condemned the Documenta for its vague assignation of blame for recent evils, including the financial crisis and incessant warfare in the Middle East; and for its exploitative relations to Athens, which unwittingly reproduced the very power relations it purported to critique.

Regina José Galindo's video loop, *The Shadow* (2017; Figure 26), may stand as a microcosm for much of the event. The artist runs endlessly around a rectangular track, chased by a Leopard battle tank (of the kind made in Kassel), at times apparently on the point of collapse, at others gathering her strength and running hard: fragile flesh before the inhuman, petrol-driven war machine

26. Regina José Galindo, *The Shadow*, 2017.

which grinds and clanks behind the artist, threatening to crush
her beneath its tracks. The work bears upon the unequal
character of the struggle against state powers, its lengthy
duration, and especially upon the spirit of resolve that
animates it.

This Documenta was unusual not just in its being staged across
two cities, since it was not stuffed with the usual suspects of the
biennial circuit. A great deal of money had been raised through
various German state sources, so that there was not the customary
reliance on the subsidy of major private galleries, which ensures
that the same stable of bankable artists are seen again and again.
Many new or rarely heard voices were seen in a display that as we
have seen showed women artists on parity with men. There was a
large showing of works by indigenous artists such as Máret Ánne
Sara who made works about Sámi protests at reindeer culls
enforced by the Norwegian state, and The Mata Aho Collective,
which makes monumental sewn works embodying Maori women's
discourse. The underlying idea behind strongly featuring
indigenous art is that much could be learned in the developed
world not just about aesthetics but also democratic procedures
and care for the environment.

Segments of the Documenta felt actively insurgent: this was especially so of some of the long and complex video pieces, which unfold little-told stories through documentation and performance. Mary Zygouri, for example, investigated the suppression of Greek communism by massacre, tellingly layering different frames of collective memory, its repression, and recovery; Angela Melitopoulos (with the collaboration of political thinker, Maurizio Lazzarato) across a number of episodes gave voice to refugees held in camps on Lesbos, and those suffering from environmental degradation caused by 'modernization' programmes in Chile; Bouchra Khalili explored resistance movements among young people, in a film that revamps Brecht to have activists tell of and perform the circumstances that forge their new political agency: 'These thick clouds can no longer hide the new beauty enveloping us', proclaims one, 'They see our beauty appearing, and they are terrified.'

A few signal works in prominent locations made clear statements of wide appeal: this was so of Olu Oguibe's obelisk celebrating the welcome of refugees in various languages; of Marta Minujín's Parthenon of banned books which dominated Friedrichplatz, once a site of Nazi book-burning (this restaged a work that had originally marked the fall of the Brazilian dictatorship); and of Hans Haacke's banners proclaiming, again in a number of languages, 'We Are (All) the People'.

If the Documenta, beyond highlighting oppression, also felt rebellious, the reason is not hard to discern: as the political centre enters crisis and is threatened by populist challenges from Left and Right, the default for cultural protest is no longer merely of melancholy complaint but, as the ice flows of mental orthodoxy crack, of opportunity. Mapping the art world against the political divide, the equivalent of the right-wing populists make flashy gewgaws for the new, time-poor masters of the universe, hoping to attach to their work the same false association of billionaires' tastes and interests with the worthy mass, as in Trump's sleight of

hand. The left cultural populists mine histories of resistance to revive models for action in the present. Those who, between the two wings, complain about the lack of respect shown to individual works of art or a deficiency of beauty, find themselves in the same position as those technocratic politicians who gaze about in wonder at the swift evaporation of the centre.

There is, however, a deep problem at the heart of the mega-events, even when driven by rigorous and radical curation. They share with the major art fair the same environmentally destructive model based on the exceptional artist and work married to the exceptional site. The same gargantuan growth and the urge to monopolize attention drives them both. It is built into their very structures, for as long as they are based on individualism and the cult of the art star. Such events could be far more collective and local: artists, almost everywhere, after all, are not in short supply.

Walter Benjamin's old point still holds: a radical art needs to do more than make politics its subject-matter; it must change the way it is made, distributed, and seen, and in the process transform both artist and viewer, and indeed the distinction between them. The beginnings of this transformation can be seen in art activism.

The branch of the Guggenheim planned to open in Abu Dhabi's Saadiyat Island museum complex is to be a massive, luxury building, designed (as in Bilbao) by Frank Gehry. The contrast between such a lavish display of wealth and the conditions of the migrant workers working on it is stark: in violation of barely enforced labour laws, many are held in debt slavery, enforced by the confiscation of their passports and, for the troublemakers, by beatings and deportation. They live in squalid communal housing, and work in hazardous circumstances. In March 2014, a group called Global Ultra Luxury Faction, in collaboration with Gulf Labor Coalition (GLC), protested these conditions by dropping thousands of bits of paper designed to look like dollar bills into the famous atrium of the New York museum. These were graced

with a picture of the design for the Abu Dhabi building, the slogan 'No Sustainable Cultural Value', and '1%' printed in each corner. Unlike the Tate reaction to protest over its attachment to BP, the Guggenheim were far from relaxed about the action, and took the extraordinary step of shutting down the museum. Further actions followed, forcing the museum to meet with GLC. It proved intransigent in pushing aside responsibility for the conditions of the workers, however, and GLC has organized a continuing boycott of the Guggenheim Abu Dhabi.

As Greg Sholette has pointed out, the extremely steep inequality of the art world, and the precarious situation of growing numbers of artists, makes them a ready reserve not just for casualized work but for protest. During the various Occupy events, and in the Movement of the Squares, they came out in force. Protest itself, now a creature of social media, has become more overtly a display of culture, and of many objects and performances that look like art. Protest borrows freely from the art world, which returns the favour. Yates McKee points out that Hirst's infamous diamond-encrusted skull was used as a placard at the Occupy site at Zucotti Park as a symbol of the 1 per cent.

In protest, performance, politics, artistic creations and recording become inextricably entangled. A key example is the book bloc, a response to police violence against anti-capitalist protestors at Seattle, Genoa, and many other places, in which shields in the form of book covers were made both to protect protestors and to display the titles of works of culture and political thought (Figure 27). Since the bloc is designed, when the police attack, to produce images of the assault on learning and culture, it is as much a performance device as a shield. As Francesco Raparelli recounts in the catalogue, *Disobedient Objects*, in Italy where the shields were first used, students and workers protesting against the Berlusconi government carried the 'books' of Petronius, Boccaccio, and Machiavelli, and indeed of books that had been dropped from curricula by the stricken Italian academy. The

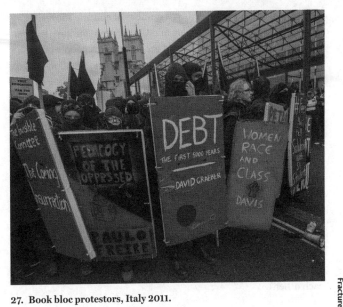

27. **Book bloc protestors, Italy 2011.**

resulting photographs were electric, and the tactic swiftly spread through Europe and the US. And, as David Graeber writes in the same catalogue, little irks the police more than the temporary sculptural figures carried by demonstrators known as 'puppets': mock monuments, often accompanied by musicians, clowns, and jugglers in a carnival atmosphere, they upstage the police, tower over them, and satirize their political masters. The police often make extraordinary efforts to seize them and smash them to pieces.

Thomas Hirschhorn has long mined the techniques, materials, and look of protest culture for his installations and discussion forums. Using cheap and readily available materials, he makes a 'poor art', which is intended to flatten hierarchies in busy, excessive collages of junk. Ambiguously individualist and autonomous, this work highlights the cultures of activism.

Black Lives Matter has pursued a number of cultural moves: its iconoclasm, as statues of slavers and Confederate military leaders fall and are abused, echoes that of the indigenous people of Chiapas, who dragged the statue of the local conquistador, Diego de Mazariegos, from its pedestal, and hauled it across San Cristóbal de las Casas, a rope tied around its neck, just as the conquistador had treated their ancestors in those same streets, centuries ago. Their decoration of the monuments that still stand is as chaotic, busy, and demotic as Hirschhorn's installations, and stands in marked contrast to the many meticulous, dignified, and grave murals that commemorate George Floyd and other victims of police violence. In both, we may glimpse a cultural utopianism, the emergence of a global humanism that prizes complex and fluid identities and at the same time registers political reaction and rising precarity. As Paul Gilroy puts it: 'multicultural ethics and politics could be premised on an agonistic, elemental vulnerability to the wrongs we visit upon each other.'

This high passion—both to make such elaborate protest works in the first place and the passion of others to destroy them—seems rare in capitalist culture. In her remarkable book, *Our Aesthetic Categories*, Sianne Ngai writes of the decline of the old experiences of the sublime and the beautiful in favour of three newly dominant modes—the zany, the cute, and the interesting which are better geared to capitalist culture. The zany is associated with production, the cute with consumption, and the merely interesting with distribution. All offer pallid and contradictory experiences, being hardly life-transforming, but rather passively consumed with a giggle, an 'ahhh', or a nod of respect. Compared to the struggles of avant-garde artists and those who sought to understand what they had made, and for whom aesthetic disputes, modes of expression, and failure to live up to ideals might be a matter of life and death, they have a faint and tenuous hold on the psyche. The grand works of contemporary art that still strive to overawe the viewer with sublime spectacle

often fall flat, or carry with them the whiff of Hollywood cliché. It may be, then, that currently the most powerful aesthetic experiences are found in the vertigo of rebellion and collective action—of art put to use in an increasingly urgent struggle to defend the environment and the future of humanity itself.

As McKee remarks, in the culture of Occupy there could be glimpsed the end of contemporary art as it dissolved into an expanding field of social engagement. Art's bewitching suspension between political use and ideal autonomy, social action and immunity, falls apart into an increasingly banal cycle of money-making opposed by a culture of overt activism. In this development, there is a foretaste of the closing stages of that compact, 'contemporary art', in a new politics and in catastrophe.

The question of art's use takes us back, naturally, to art's freedom. That the very concerns of the mainstream of art—creativity, enlightenment, criticality, self-criticism—are as instrumentally grounded as what they serve to conceal—business, state triage, and war—is the matter that had to be concealed. If it remained so for so long, it was because the local liberation offered in the production of art, and its enjoyment, were genuine. Bourdieu cites a letter by Flaubert on art's freedom:

> That is why I love Art. There, at least, everything is freedom, in this world of fictions. There one is satisfied, does everything, is both a king and his subjects, active and passive, victim and priest. No limits; humanity is for you a puppet with bells you make ring at the end of his sentence like a buffoon with a kick.

Flaubert more than implies that the free mastery of the artist (and reader or viewer) is a cruel power. In Bourdieu's analysis, Flaubert's freedom, and that of the avant-garde in general, was purchased at the price of actual disconnection from the world of the economy. Other bohemian writers were the main and grossly inadequate market for such work, and books were written in

deliberate defiance of bourgeois understanding. The autonomy of art was carved out of a reaction against both elevated bourgeois writing and engaged, realist literature; acclaim was only—if ever—achieved after the long passage of time, as new avant-garde forms displaced and familiarized the old. It is easy to see that the conditions for that freedom no longer exist in the art world. The plausibility and power of art's freedom are on the wane. Among the opening remarks of *Aesthetic Theory*, Adorno has this to say about artistic freedom: 'absolute freedom in art, always limited to a particular, comes into contradiction with the perennial unfreedom of the whole'. Until that wider unfreedom is confronted, the particular freedoms of art run through the fingers like sand. To break with the autonomy of free art is to remove one of the masks of free trade. Or to put it the other way around, if capitalist free trade is to be abandoned as a model for global development, so must its ally, free art.

References

Chapter 1: A zone of freedom?

Rasheed Araeen, *The Other Story: Afro-Asian Artists in Post-War Britain* (London: Hayward Gallery, 1989).

Giovanni Arrighi, *The Long Twentieth Century: Money, Power and the Origins of Our Times* (London: Verso, 2010).

The Art Sales Index: www.art-sales-index.com

Pierre Bourdieu, *The Rules of Art: Genesis and Structure of the Literary Field* (Cambridge: Polity Press, 1996), p. xiv.

Brooklyn Museum, *Global Feminisms: New Directions in Contemporary Art* (New York, 2007).

Benjamin Buchloh, 'Critical Reflections', *Artforum*, vol. 35, no. 5, January 1997, pp. 68–9, 102.

Centre Georges Pompidou, *Magiciens de la terre* (Paris: Editions de Centre Pompidou, 1989).

Ta-Nehisi Coates, *We Were Eight Years in Power: An American Tragedy* (London: Hamish Hamilton, 2017).

Douglas Davis, 'Multicultural Wars', *Art in America*, vol. 83, no. 2, February 1995, pp. 35–9, 41, 43, 45.

Jacques Derrida, *Of Grammatology*, tr. Gayatri Chakravorty Spivak (Baltimore: Johns Hopkins University Press, 1976), pt. II.

Jean Fisher, 'The Other Story and the Past Imperfect', *Tate Papers*, no.12, Autumn 2009: https://www.tate.org.uk/research/publications/tate-papers/no-12/the-other-story-and-the-past-imperfect

Coco Fusco, *The Bodies That Were Not Ours and Other Writings* (London: IVA and Routledge, 2001).

Jane F. Gerhard, *The Dinner Party: Judy Chicago and the Power of Popular Feminism, 1970–2007* (Athens: University of Georgia Press, 2013).

Thelma Golden, *Black Male: Representations of Masculinity in Contemporary American Art* (New York: Whitney Museum of American Art, 1994).

Rosalind Krauss, '*A Voyage on the North Sea': Art in the Age of the Post-Medium Condition* (London: Thames & Hudson, 1999).

Karl Marx and Frederick Engels, *The Communist Manifesto: A Modern Edition* (London: Verso, 1998), pp. 39–40.

Victor Misiano, 'An Analysis of "Tusovka": Post-Soviet Art of the 1990s', in Gianfranco Maraniello (ed.), *Art in Europe, 1990–2000* (Milan: Skira, 2002).

David Morley and Kuan-Hsing Chen (eds.), *Stuart Hall: Critical Dialogues in Cultural Studies* (London: Routledge, 1996).

Julie H. Reiss, *From Margin to Center: The Spaces of Installation Art* (Cambridge, MA: The MIT Press, 1999).

'A Sonorous Subtlety: Kara Walker with Kara Rooney', *The Brooklyn Rail*, 6 May 2014: https://brooklynrail.org/2014/05/art/kara-walker-with-kara-rooney

Donald Sassoon, 'On Cultural Markets', *New Left Review*, new series, no. 17, September/October 2002, pp. 113–26.

Donald Sassoon, *The Culture of the Europeans: From 1800 to the Present* (London: Harper Press, 2006).

Joseph Stiglitz, *Globalization and Its Discontents* (London: Allen Lane, 2002).

Wolfgang Streeck, *Buying Time: The Delayed Crisis of Democratic Capitalism* (London: Verso, 2014).

Martin Wolf, *The Shifts and the Shocks: What We've Learned from the Financial Crisis* (London: Allen Lane, 2014).

Chapter 2: New world order

Maria Alyokhina, *Riot Days* (London: Penguin Books, 2017).

Carol Becker, 'The Romance of Nomadism: A Series of Reflections', *Art Journal*, vol. 58, no. 2, Summer 1999, pp. 22–9.

Beijing Contemporary Art Foundation, *Other Future: 56th International Art Exhibition, Venice Biennale: China Pavilion* (Beijing: Beijing Contemporary Art Foundation, 2015).

Alexander Brener, 'Ticket that Exploded': http://www.ljudmila.org/interpol/intro2.htm

Jen Budney, 'Who's It For? The 2nd Johannesburg Biennale', *Third Text*, no. 42, Spring 1998, pp. 88–94.

Ilya Budraitskis, 'A Heritage Without an Heir', in Elena Zaytseva and Alex Anikina (eds.), *Cosmic Shift: Russian Contemporary Art Writing* (London: Zed Books, 2017).

Mikhail Bulgakov, *The Heart of a Dog*, tr. Mirra Ginsburg (London: Picador, 1990).

Jasmine Chohan, *La Bienal de la Habana: The Rise of the Collateral*, PhD Thesis, Courtauld Institute of Art, University of London 2020.

Noam Chomsky, *Deterring Democracy* (London: Vintage, 1992).

Eugenio Valdés Figueroa, 'Trajectories of a Rumour: Cuban Art in the Postwar Period', in Holly Block (ed.), *Art Cuba: The New Generation*, tr. Cola Franzen and Marguerite Feitlowitz (New York: Harry N. Abrams Inc., 2001), p. 20.

Jean Fisher, quoted in Kobena Mercer, 'Ethnicity and Internationality: New British Art and Diaspora-Based Blackness', *Third Text*, no. 49, Winter 1999–2000, pp. 51–62.

Foundation Manifesta 8 Region of Murcia, *Manifesta 8: The European Biennial of Contemporary Art* (Milan: Silvana Editoriale, 2010).

Coco Fusco, *The Bodies That Were Not Ours and Other Writings* (London: IVA and Routledge, 2001), p. 156.

Eduardo Galeano, *Memory of Fire*, tr. Cedric Belfrage (London: Quartet Books, 1995).

Charles Green and Anthony Gardner, *Biennials, Triennials and documenta: The Exhibitions that Changed Contemporary Art* (Chichester: Wiley Blackwell, 2016).

Hou Hanrou, interviewed in Franklin Sirmans, 'Johannesburg Biennale: Meet the Curators of "Trade Routes: History and Geography"', *Flash Art*, vol. 30, no. 190, October 1997, pp. 78–82.

Jonathan Harris, ed., *Globalization and Contemporary Art* (Chichester: Wiley-Blackwell, 2011).

Fredric Jameson, 'Marxism and Postmodernism', in *The Cultural Turn: Selected Writings on the Postmodern, 1983–1998* (London: Verso, 1998).

Ronald Kolb and Shwetal A. Patel, *On Curating: Global Biennial Survey 2018*, no. 39, June 2018: http://www.on-curating.org/issue-39.html#.XKscH5hKguU

Liverpool Biennial of International Contemporary Art and Tate Liverpool, *1st Liverpool Biennial of International Contemporary*

Art: Trace (Liverpool: Liverpool Biennial of International Contemporary Art and Tate Liverpool, 1999).

Rosa Martínez, cited in Carlos Basualdo, 'Launching Site', *Artforum*, vol. 37, no. 10, Summer 1999, pp. 39–40, 42.

Thomas McEvilley, 'Report from Johannesburg: Towards a World-Class City?', *Art in America*, vol. 83, no. 9, September 1995, pp. 45–7, 49.

David McNeill, 'Planet Art: Resistances and Affirmation in the Wake of "9/11"', *Australian and New Zealand Journal of Art*, vol. 3, no. 2, 2002, pp. 11–32.

Charles Merewether, 'Naming Violence in the Work of Doris Salcedo', *Third Text*, no. 24, Autumn 1993, pp. 31–44.

Gao Minglu, 'Extensionality and Intentionality in a Transnational Cultural System', *Art Journal*, vol. 57, no. 4, Winter 1998, pp. 36–9.

Gerardo Mosquera, 'New Cuban Art Y2K', in Holly Block (ed.), *Art Cuba: The New Generation*, tr. Cola Franzen and Marguerite Feitlowitz (New York: Harry N. Abrams Inc., 2001), p. 13.

Moderna Musset, *Organising Freedom: Nordic Art of the '90s* (Stockholm, 2000).

Alexandra Munroe, Philip Tinari, and Hou Hanrou, *Art and China After 1989: Theater of the World* (New York: Guggenheim Museum Publications, 2018).

Katya Sander and Simon Sheikh (eds.), *We Are All Normal (and We Want Our Freedom): A Collection of Contemporary Nordic Artists' Writings* (London: Black Dog Publishing, 2001), p. 70.

Tony Wood, *Russia Without Putin: Money, Power and the Myths of the Cold War* (London: Verso, 2018).

Måns Wrange, 'To Change the World: On Statistical Averages, the Art of Social Engineering and Political Lobbying', in Katya Sander and Simon Sheikh (eds.), *We Are All Normal (and We Want Our Freedom): A Collection of Contemporary Nordic Artists' Writings* (London: Black Dog Publishing, 2001). See also www.averagecitizen.org

Chin-tao Wu, 'Biennials without Borders', *New Left Review*, no. 57, May/June 2009, pp. 107–15.

Slavoj Žižek, 'Multiculturalism, or, the Cultural Logic of Multinational Capitalism', *New Left Review*, no. 225, September/October 1997, pp. 28–51.

Chapter 3: Consuming culture

Theodor W. Adorno, *Negative Dialectics*, tr. E. B. Ashton (London: Routledge, 1973).

Theodor W. Adorno, 'Free Time', in *The Culture Industry: Selected Essays on Mass Culture*, ed. J. M. Bernstein (London: Routledge, 1991).

Dave Beech, *Art and Value: Art's Economic Exceptionalism in Classical, Neoclassical and Marxist Economics* (Leiden: Brill, 2015).

Luc Boltanski and Eve Chiapello, *The New Spirit of Capitalism*, tr. Gregory Elliott (London: Verso, 2006).

Benjamin H. D. Buchloh, 'Moments of History in the Work of Dan Graham' and 'Parody and Appropriation in Picabia, Pop, and Polke', in *Neo-Avantgarde and Culture Industry: Essays on European and American Art from 1955 to 1975* (Cambridge, MA: October, 2000).

Benvenuto Cellini, *My Life*, tr. Julia Conway Bondanella and Peter Bondanella (Oxford: Oxford University Press, 2002).

Claude Closky, www.sittes.net/links

Dallas Museum of Art and Metropolitan Museum of Art, *Thomas Struth, 1977–2002*, Dallas and New York: Dallas Museum of Art and Metropolitan Museum of Art, 2002.

Diedrich Diederichsen, 'The Boundaries of Art Criticism: Academicism, Visualism and Fun', in Jürgen Bock (ed.), *From Work to Text: Dialogues on Practise and Criticism in Contemporary Art* (Lisbon: Fundaçaõ Centro Cultural de Belém, 2002).

Marcel Duchamp, 'Apropos of "Ready-mades"', in Michel Sanouillet and Elmer Peterson (eds.), *The Essential Writings of Marcel Duchamp* (London: Thames and Hudson, 1975).

Thomas Frank and Matt Weiland (eds.), *Commodify Your Dissent: Salvos from The Baffler* (New York: W. W. Norton, 1997).

Michael Fried, 'Art and Objecthood', *Artforum*, vol. 5, no. 10, Summer 1967, pp. 12–23.

Marta Gnyp, *The Shift: Art and the Rise to Power of Contemporary Collectors* (Stockholm: Art and Theory Publishing, 2015).

Isabelle Graw, *High Price: Art between the Market and Celebrity Culture* (Berlin: Sternberg Press, 2009).

Boris Groys, *Art Power* (Cambridge, MA: The MIT Press, 2008).

Boris Groys, 'The Artist as Consumer', in Centro di Cultura Contemporanea Strozzina, *Arte, Prezzo e Valore: Arte Contemporanea e Mercato* (Florence: Silvana Editoriale, 2008).

Michael Hardt and Antonio Negri, *Empire* (Cambridge, MA: Harvard University Press, 2000).

Fredric Jameson, *Postmodernism or, the Cultural Logic of Late Capitalism* (London: Verso, 1991), chapter 1.

David Joselit, *After Art* (Princeton, NJ: Princeton University Press, 2013).

Naomi Klein, *No Logo: Taking Aim at the Brand Bullies* (London: Flamingo, 2000).

Pamela M. Lee, *New Games: Postmodernism After Contemporary Art* (New York: Routledge, 2013).

Fernand Léger, 'The Machine Aesthetic: The Manufactured Object, the Artisan, and the Artist (1924)', in *Functions of Painting*, ed. Edward F. Fry (London: Thames and Hudson, 1973).

Karl Marx, *Grundrisse: Foundations of the Critique of Political Economy (Rough Draft)*, tr. Martin Nicolaus (Harmondsworth: Penguin Books, 1973).

Karl Marx, *Capital: A Critique of Political Economy, Volume I*, tr. Ben Fowkes (Harmondsworth: Penguin Books, 1976), pp. 176–7.

Vladimir Mayakovsky, 'Broadening the Verbal Basis', *Lef*, no. 10, 1927; reprinted in Anna Lawton (ed.), *Russian Futurism through Its Manifestoes, 1912–1928* (Ithaca, NY: Cornell University Press, 1988).

Martha Rosler, 'Video: Shedding the Utopian Moment', in Doug Hall and Sally Jo Fifer (eds.), *Illuminating Video: An Essential Guide to Video Art* (New York: Aperture and Bay Area Video Coalition, 1990), p. 49.

Susan Sontag, 'Notes on "Camp"', in *Against Interpretation* [1961] (London: Vintage, 1994).

Tate Liverpool, *Shopping: A Century of Art and Consumer Culture*, ed. Christoph Grunenberg and Max Hollein (Ostfildern-Ruit: Hatje Cantz Publishers, 2002).

Wolfgang Ulrich, 'Icons of Capitalism: How Prices Make Art', in Centro di Cultura Contemporanea Strozzina, *Arte, Prezzo e Valore: Arte Contemporanea e Mercato* (Florence: Silvana Editoriale, 2008).

Walker Art Center, *Let's Entertain: Life's Guilty Pleasures* (Minneapolis: Walker Art Center, 2000).

Andy Warhol, *The Philosophy of Andy Warhol (From A to B & Back Again)* (New York: Harcourt, Brace, Jovanovich, 1975).

Renate Wiehager (ed.), *Sylvie Fleury* (Osfildern-Ruit: Cantz, 1999).

Chin-tao Wu, 'Hermés in Asia: Haute Couture, High Art and the Marketplace', *Oxford Art Journal*, vol. 39, no. 3, December 2016, pp. 441–55.

Joann Wypijewski, *Painting by Numbers: Komar and Melamid's Scientific Guide to Art* (New York: Farrar, Straus, and Giroux, 1997).

Chapter 4: Uses and prices of art

Hans Abbing, *Why Are Artists Poor? The Exceptional Economy of the Arts* (Amsterdam: Amsterdam University Press, 2002), p. 286.

Georgina Adam, *Dark Side of the Boom: The Excesses of the Art Market in the 21st Century* (London: Lund Humphries, 2017).

Alexander Alberro, *Conceptual Art and the Politics of Publicity* (Cambridge, MA: The MIT Press, 2003).

Walter Benjamin, *The Arcades Project*, tr. Howard Eiland and Kevin McLaughlin (Cambridge, MA: The Belknap Press of Harvard University Press, 1999).

Pierre Bourdieu, *Distinction: A Social Critique of the Judgement of Taste*, tr. Richard Nice (London: Routledge, 1984).

Pierre Bourdieu and Alain Darbel, *The Love of Art: European Art Museums and Their Public*, tr. Caroline Beattie and Nick Merriman (Cambridge: Polity Press, 1991).

Kim Bradley, 'The Deal of the Century', *Art in America*, vol. 85, no. 7, July 1997, pp. 48–55, 105–6.

Robert Brenner, *The Boom and the Bubble: The US in the Global Economy* (London: Verso, 2001).

Benjamin Buchloh, 'Critical Reflections', *Artforum*, vol. 35, no. 5, January 1997, pp. 68–9, 102.

Jo Clarke, Mel Evans, Hayley Newman, Kevin Smith, and Glen Tarman (eds.), *Culture Beyond Oil* (London: Art Not Oil, Liberate Tate, and Platform, 2011).

Neil Cummings and Marysia Lewandowska, *The Value of Things* (Basel: Birkhäuser, 2000).

Deutsche Guggenheim, *Jeff Koons: Easyfun and Ethereal* (Berlin, 2000), p. 56.

Adrian Ellis, 'Museum Boom Will Be Followed by Bust', *The Art Newspaper*, no. 116, July/August 2001, p. 14.

Chrystia Freeland, *Plutocrats* (New York: The Penguin Press, 2012).

Coco Fusco, *The Bodies That Were Not Ours and Other Writings* (London: IVA and Routledge, 2001).

Max Haiven, *Art After Money, Money After Art: Creative Strategies Against Financialization* (London and Toronto: Pluto Press and Between the Lines, 2018).

Dave Hickey, *Air Guitar: Essays on Art and Democracy* (Los Angeles: Art Issues Press, 1997).

Kassel, Internationale Austellung, *Documenta IX* (Stuttgart: Edition Cantz, 1992).

Sophia Kishkovsky, 'Moscow Biennale Pokes Fun at Consumers and Politicians', *New York Times*, 10 March 2007.

Naomi Klein, *No Logo: Taking Aim at the Brand Bullies* (London: Flamingo, 2000).

Niklas Luhmann, *Art as a Social System*, tr. Eva M. Knodt (Stanford: Stanford University Press, 2000).

Cynthia MacMullin, 'The Influence of Bi-Nationalism on the Art and Economy of Contemporary Mexico', in Zdenek Felix, Beate Hentschel, and Dirk Luckow (eds.), *Deichtorhallen Hamburg, Art and Economy* (Ostfildern-Ruit: Hatje Cantz, 2002).

Neil De Marchi and Craufurd D. W. Goodwin, *Economic Engagements with Art* (Durham, NC: Duke University Press, 1999).

Mark W. Rectanus, *Culture Incorporated: Museums, Artists and Corporate Sponsorships* (Minneapolis: University of Minnesota Press, 2002).

Gerald Reitlinger, *The Economics of Taste: The Rise and Fall of Picture Prices, 1760–1960* (London: Barrie & Rockliff, 1961).

Franz Schultheis, Erwin Single, Stephan Egger, and Thomas Mazzurana, *When Art Meets Money: Encounters at Art Basel* (Cologne: Walther König, n.d.).

Howard Singerman, *Art Subjects: Making Artists in the American University* (Berkeley: University of California Press, 1999).

Julian Stallabrass, 'The Branding of the Museum', *Art History*, vol. 37, no. 1, February 2014, pp. 148–65.

Leo Steinberg, *Other Criteria: Confrontations with Twentieth-Century Art* (New York: Oxford University Press, 1972).

Sarah Thornton, *Seven Days in the Art World* (London: Granta, 2008).

Peter Watson, *From Manet to Manhattan: The Rise of the Modern Art Market* (London: Hutchinson, 1992).

Contemporary Art

Chin-tao Wu, *Privatising Culture: Corporate Art Intervention since the 1980s* (London: Verso, 2001).

Chapter 5: The end of the end of History

Giorgio Agamben, 'What Is the Contemporary?', in *What Is an Apparatus? and Other Essays*, tr. David Kishik and Stefan Pedatella (Stanford: Stanford University Press, 2009).

Nora M. Alter, *The Essay Film After Fact and Fiction* (New York: Columbia University Press, 2018).

Pierre Bourdieu, *The Rules of Art: Genesis and Structure of the Literary Field* (Cambridge: Polity Press, 1996).

Arthur C. Danto, *After the End of Art: Contemporary Art and the Pale of History* (Princeton, NJ: Princeton University Press, 1997).

Diedrich Diedrichsen, 'The Boundaries of Art Criticism: Academicism, Visualism and Fun', in Jürgen Bock (ed.), *From Work to Text: Dialogues on Practise and Criticism in Contemporary Art* (Lisbon: Fundaçaõ Centro Cultural de Belém, 2002).

Hal Foster, *Design and Crime (and Other Diatribes)* (London: Verso, 2002).

Francis Fukuyama, *The End of History and the Last Man* (New York: The Free Press, 1992).

Renée Green, 'Introductory Notes of a Reader and "A Contemporary Moment"', in Jürgen Bock (ed.), *From Work to Text: Dialogues on Practise and Criticism in Contemporary Art* (Lisbon: Fundaçaõ Centro Cultural de Belém, 2002).

Gareth Harris, 'Why the Rise of Christopher Wool?', *The Art Newspaper*, issue 249, September 2013.

Noah Horowitz, *Art of the Deal: Contemporary Art in a Global Financial Market* (Princeton, NJ: Princeton University Press, 2011).

David Hume, 'An Inquiry Concerning Human Understanding', in *On Human Nature and the Understanding*, (ed.) Antony Flew (London: Collier, 1962).

Thomas McEvilley, Art and Otherness: Crisis in Cultural Identity (Kingston, NY: Documentext and McPherson, 1992), pp. 12 and 145.

Oliver Marchat, 'Schröder's Return: Documenta 12 as a German Summer-Camp of Reconciliation', in Irene Montero (ed.), *¿Modernidad? ¡Vida! Documenta 12* (Madrid: Brumaria, 2007), pp. 375–81.

Richard Meyer, *What Was Contemporary Art?* (Cambridge, MA: The MIT Press, 2013).

Museum of Modern Art, '*Primitivism' in Twentieth Century Art: Affinity of the Tribal and the Modern* (New York, 1984).

Peter Schjeldahl, 'Writing on the Wall: A Christopher Wool Retrospective', *The New Yorker*, 28 October 2013.

Howard Singerman, *Art Subjects: Making Artists in the American University* (Berkeley: University of California Press, 1999), p. 186.

Terry Smith, *What Is Contemporary Art?* (Chicago and London: The University of Chicago Press, 2009).

Robert Venturi, Denise Scott Brown, and Steven Izenour, *Learning from Las Vegas: The Forgotten Symbolism of Architectural Form* (Cambridge, MA: The MIT Press, 1977).

Chapter 6: Fracture

Theodor W. Adorno, *Aesthetic Theory*, tr. Robert Hullot-Kentor (Minneapolis: University of Minnesota Press, 1997).

Rachel Baker: http://www.irational.org/tm/archived/tesco/front2.html

Walter Benjamin, 'The Author as Producer' (1934), in *Selected Writings, Volume 2*, 1927–1934, (ed.) Michael W. Jennings, Howard Eiland, and Gary Smith (Cambridge, Mass.: The Belknap Press of Harvard University Press, 1999).

La Biennale di Venezia, *56th International Art Exhibition: All the World's Futures* (Venice: Fondazione La Biennale di Venezia, 2015).

Claire Bishop, *Artificial Hells: Participatory Art and the Politics of Spectatorship* (London: Verso, 2012).

Pierre Bourdieu, *The Rules of Art: Genesis and Structure of the Literary Field* (Cambridge: Polity Press, 1996), p. 26.

Nicolas Bourriaud, *Relational Aesthetics*, tr. Simon Pleasance and Fronza Woods (Dijon: Les Presses du réel, 2002).

Christina Braun, *Thomas Hirschhorn: A New Political Understanding of Art?*, trans. Steven Lindberg (Dartmouth: Dartmouth College Press, 2018).

Benjamin H. D. Buchloh, *Neo-Avantgarde and Culture Industry: Essays on European and American Art from 1955 to 1975* (Cambridge, MA: October, 2000).

Alexander Cockburn, Jeffrey St Clair, and Allan Sekula, *Five Days that Shook the World: Seattle and Beyond* (London: Verso, 2000).

Digital Hijack: http://146.228.204.72:8080/

eToys dispute: http://www.toywar.com/

Catherine Flood and Gavin Grindon (eds.), *Disobedient Objects* (London: V&A Publishing, 2014).

Andrea Fraser, 'L'1 %, C'est Moi', *Texte zur Kunst*, no. 83, September 2011, pp. 114–27.

Paul Gilroy, *After Empire: Melancholia or Convivial Culture?* (Abingdon: Routledge, 2004).

Serge Guilbaut, *How New York Stole the Idea of Modern Art: Abstract Expressionism, Freedom, and the Cold War*, tr. Arthur Goldhammer (Chicago: University of Chicago Press, 1983).

Michael Hardt and Antonio Negri, *Empire* (Cambridge, MA: Harvard University Press, 2000).

Quinn Latimer and Adam Szymczyk (eds.), *The documenta 14 Reader* (Kassel and Munich: documenta and Prestel Verlag, 2017).

Yates McKee, Strike Art: Contemporary Art and the Post-Occupy Condition (London: Verso, 2016).

Karl Marx and Friedrich Engels, *The German Ideology* (Amherst, NY: Prometheus Books, 1998).

Walter D. Mignolo, *The Darker Side of Western Modernity: Global Futures, Decolonial Options* (Durham, NC: Duke University Press, 2011).

Sianne Ngai, *Our Aesthetic Categories: Zany, Cute, Interesting* (Cambridge, MA: Harvard University Press, 2012).

Gregory Sholette, *Delirium and Resistance: Activist Art and the Crisis of Capitalism*, ed. Kim Charnley (London: Pluto Press, 2017).

Julian Stallabrass, 'The Dead, Our Dead: Murals and Banners of the Zapatistas', *Third Text*, no. 38, Spring 1997, pp. 55–64.

Index

For the benefit of digital users, indexed terms that span two pages (e.g., 52–53) may, on occasion, appear on only one of those pages.

Contemporary Art

FASHION
A Very Short Introduction
Rebecca Arnold

Fashion is a dynamic global industry that plays an important role in the economic, political, cultural, and social lives of an international audience. It spans high art and popular culture, and plays a significant role in material and visual culture. This book introduces fashion's myriad influences and manifestations. Fashion is explored as a creative force, a business, and a means of communication. From Karl Lagerfeld's creative reinventions of Chanel's iconic style to the multicultural reference points of Indian designer Manish Arora, from the spectacular fashion shows held in nineteenth century department stores to the mix-and-match styles of Japanese youth, the book examines the ways that fashion both reflects and shapes contemporary culture.

> 'Her fascinating little book makes a good framework for independent study and has a very useful bibliography.'
>
> **Philippa Stockley, Times Literary Supplement**

www.oup.com/vsi

BEAUTY
A Very Short Introduction
Roger Scruton

In this *Very Short Introduction* the renowned philosopher Roger Scruton explores the concept of beauty, asking what makes an object - either in art, in nature, or the human form - beautiful, and examining how we can compare differing judgements of beauty when it is evident all around us that our tastes vary so widely. Is there a right judgement to be made about beauty? Is it right to say there is more beauty in a classical temple than a concrete office block, more in a Rembrandt than in last year's Turner Prize winner? Forthright and thought-provoking, and as accessible as it is intellectually rigorous, this introduction to the philosophy of beauty draws conclusions that some may find controversial, but, as Scruton shows, help us to find greater sense of meaning in the beautiful objects that fill our lives.

A fascinating book, which I heartily recommend.

Brya Wilson, Readers Digest

EARLY MUSIC
A Very Short Introduction
Thomas Forrest Kelly

The music of the medieval, Renaissance, and baroque periods have been repeatedly discarded and rediscovered ever since they were new. In recent years interest in music of the past has taken on particular meaning, representing two specific trends: first, a rediscovery of little-known underappreciated repertories, and second, an effort to recover lost performing styles. In this VSI, Thomas Forrest Kelly frames chapters on the forms, techniques, and repertories of the medieval, Renaissance, and baroque periods with discussion of why old music has been and should be revived, along with a short history of early music revivals.

www.oup.com/vsi

CLASSICAL MYTHOLOGY
A Very Short Introduction
Helen Morales

From Zeus and Europa, to Diana, Pan, and Prometheus, the myths of ancient Greece and Rome seem to exert a timeless power over us. But what do those myths represent, and why are they so enduringly fascinating? This imaginative and stimulating *Very Short Introduction* is a wide-ranging account, examining how classical myths are used and understood in both high art and popular culture, taking the reader from the temples of Crete to skyscrapers in New York, and finding classical myths in a variety of unexpected places: from Arabic poetry and Hollywood films, to psychoanalysis, the bible, and New Age spiritualism.

DOCUMENTARY FILM
A Very Short Introduction
Patricia Aufderheide

Beginning with an overview of the central issues of documentary filmmaking--its definitions and purposes, its forms and founders--Aufderheide focuses on several of its key subgenres, including public affairs films, government propaganda (particularly the works produced during World War II), historical documentaries, and nature films. Her thematic approach allows readers to enter the subject matter through the kinds of films that first attracted them to documentaries, and it permits her to make connections between eras, as well as revealing the ongoing nature of documentary's core controversies involving objectivity, advocacy, and bias.

> Always clear and concise...a welcome addition to the *Very Short Introductions* series.
>
> The Observer

www.oup.com/vsi

ADVERTISING
A Very Short Introduction
Winston Fletcher

The book contains a short history of advertising and an explanation of how the industry works, and how each of the parties (the advertisers , the media and the agencies) are involved. It considers the extensive spectrum of advertisers and their individual needs. It also looks at the financial side of advertising and asks how advertisers know if they have been successful, or whether the money they have spent has in fact been wasted. Fletcher concludes with a discussion about the controversial and unacceptable areas of advertising such as advertising products to children and advertising products such as cigarettes and alcohol. He also discusses the benefits of advertising and what the future may hold for the industry.

www.oup.com/vsi